Enchanted Childhood

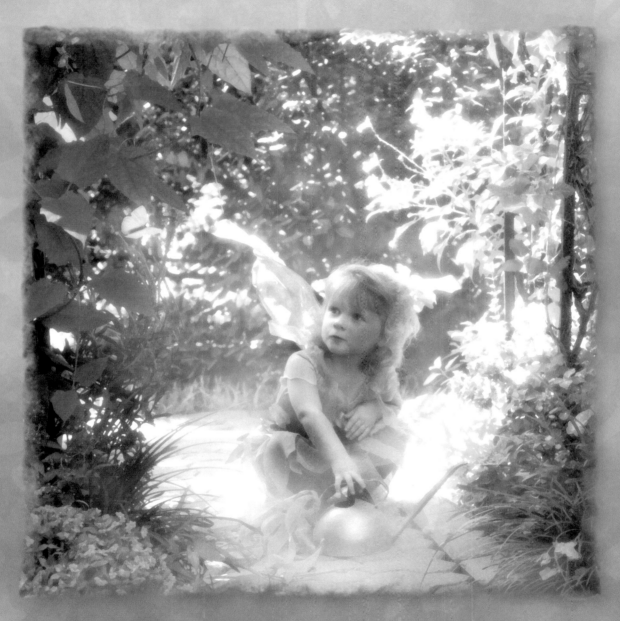

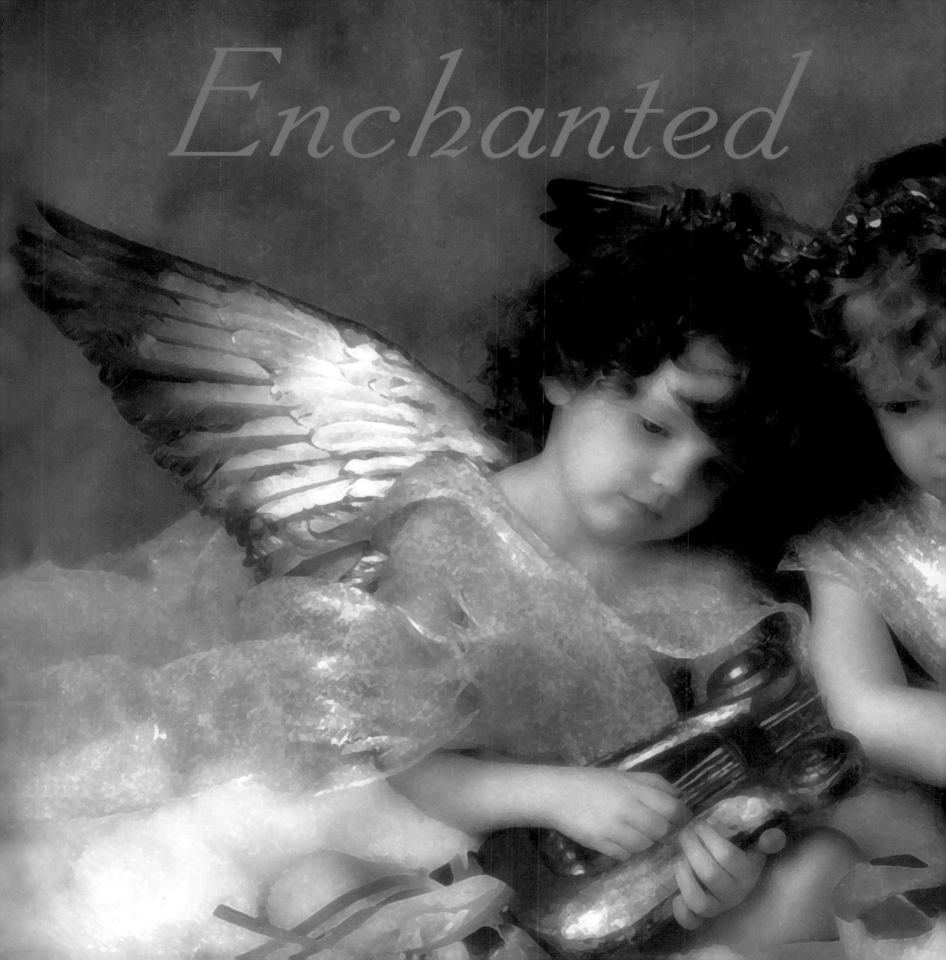

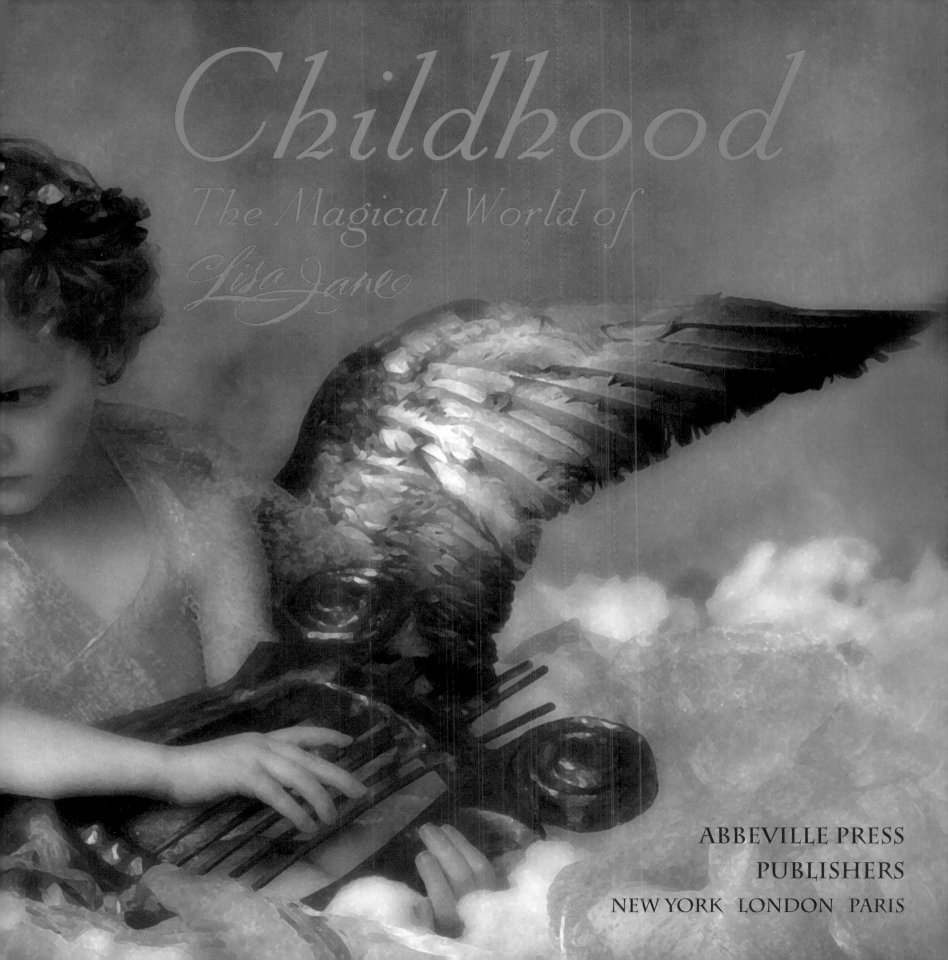

Childhood

The Magical World of

Lisa Jane

ABBEVILLE PRESS

PUBLISHERS

NEW YORK LONDON PARIS

This book is dedicated to my husband and three sons.
May they always remain young at heart.

Editor: Nancy Grubb
Designer: Patricia Fabricant
Production Editor: Owen Dugan
Production Manager: Lou Bilka

First edition
2 4 6 8 10 9 7 5 3 1

Library of Congress Cataloging-in-Publication Data
Jane, Lisa.
 Enchanted childhood : the magical world of Lisa Jane.
 p. cm.
 ISBN 0-7892-0493-2
 1. Photography of children. 2. Jane, Lisa. I. Title.
TR681.C5J36 1999
779'.25—dc21 98-31013

Preface

"Know you what it is to be a child? . . . It is to believe in love, to believe in loveliness, to believe in belief; it is to be so little that the elves can reach to whisper in your ear; it is to turn pumpkins into coaches, and mice into horses, lowliness into loftiness, and nothing into everything, for each child has its fairy godmother in its soul."

Francis Thompson Shelley

In a young heart, fairies still flit around sprinkling magic dust, mermaids sun themselves on mysterious seashores, baby angels laugh as they play heavenly hymns on tiny harps, and a kiss from a princess really does turn a frog into prince charming. Take a journey with me back to the dreamy days of childhood, when all the world was a fairy tale.

Through my photography, I hope to remind you of that wondrous time when imaginations ran wild and anything was possible. In today's fast-paced society we sometimes forget to cherish and nurture those things that should be most precious to us: the children who belong to us and the children who live within us.

For more then twenty years I have been a portrait photographer specializing in children. My goal has been to capture the essence of childhood that lies within each child before he or she disappears into adulthood. All of the children I photograph touch my soul with their sweetness and their delightfully distinctive personalities. I like to think of these portraits as windows to their souls, wherein live all things beautiful, innocent, and magical. Share with me now this enchanted childhood. I hope you will keep it in your heart forevermore. . . .

Lisa Jane

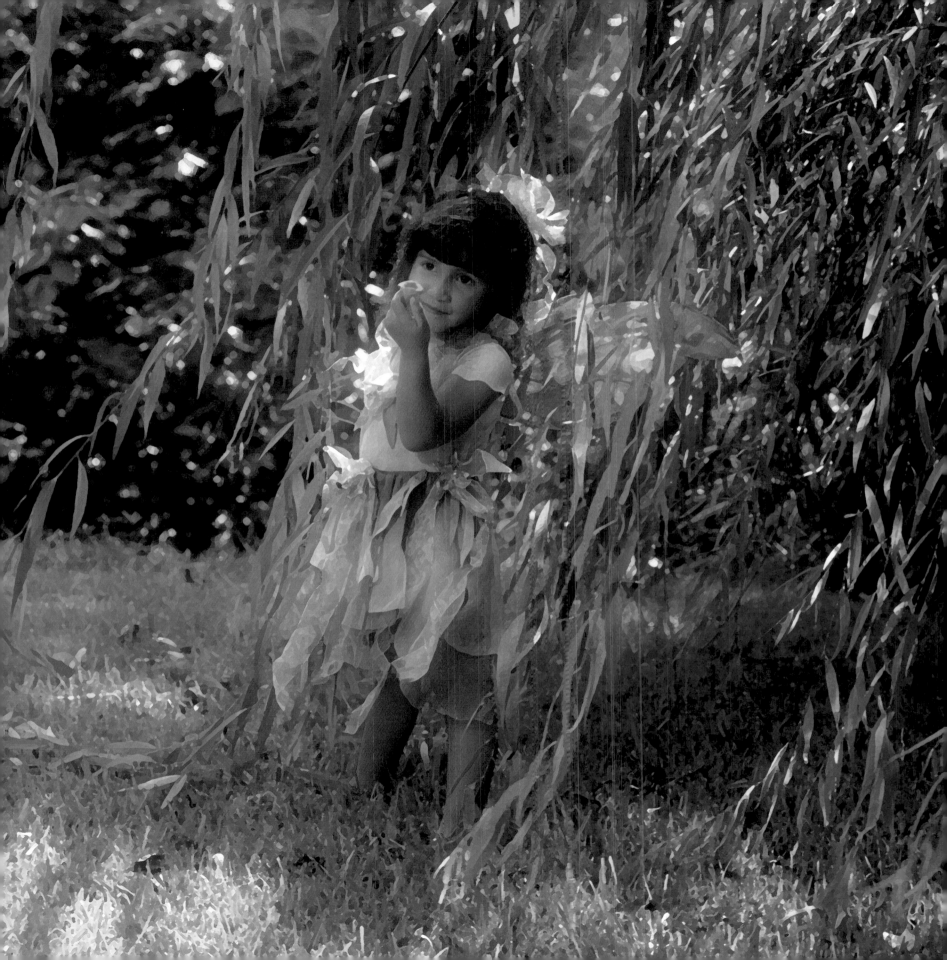

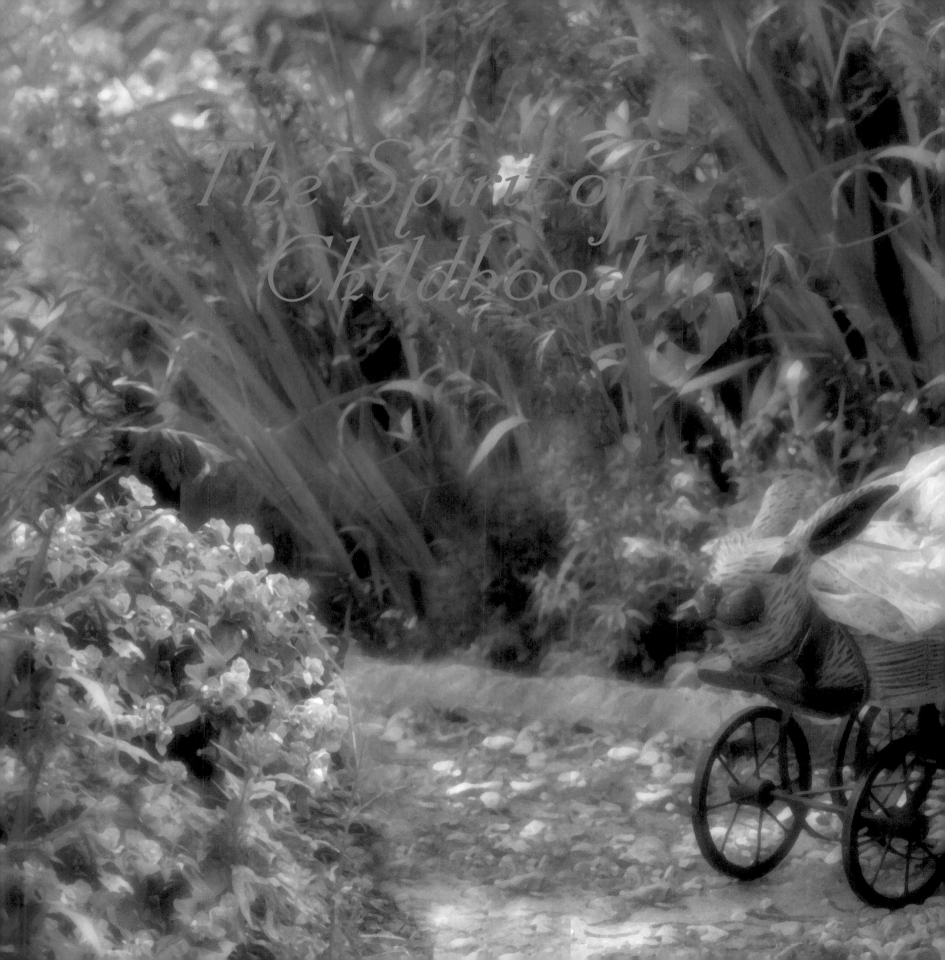

The Spirit of
Childhood

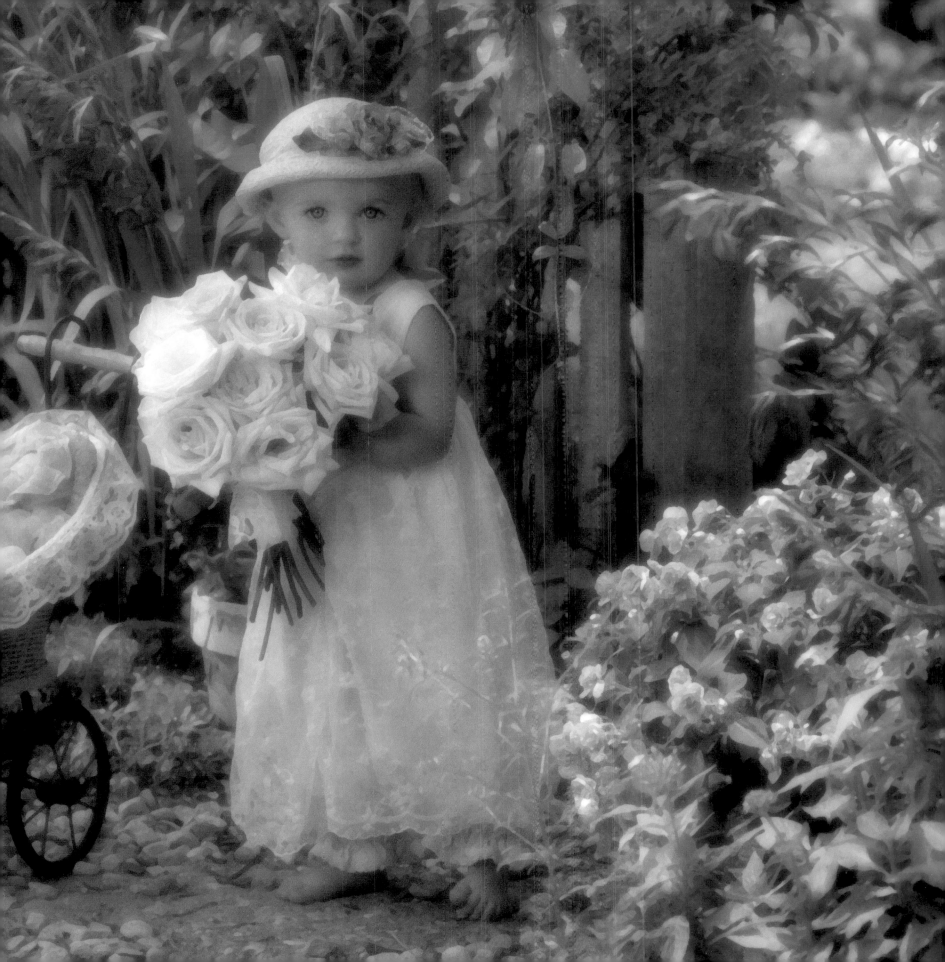

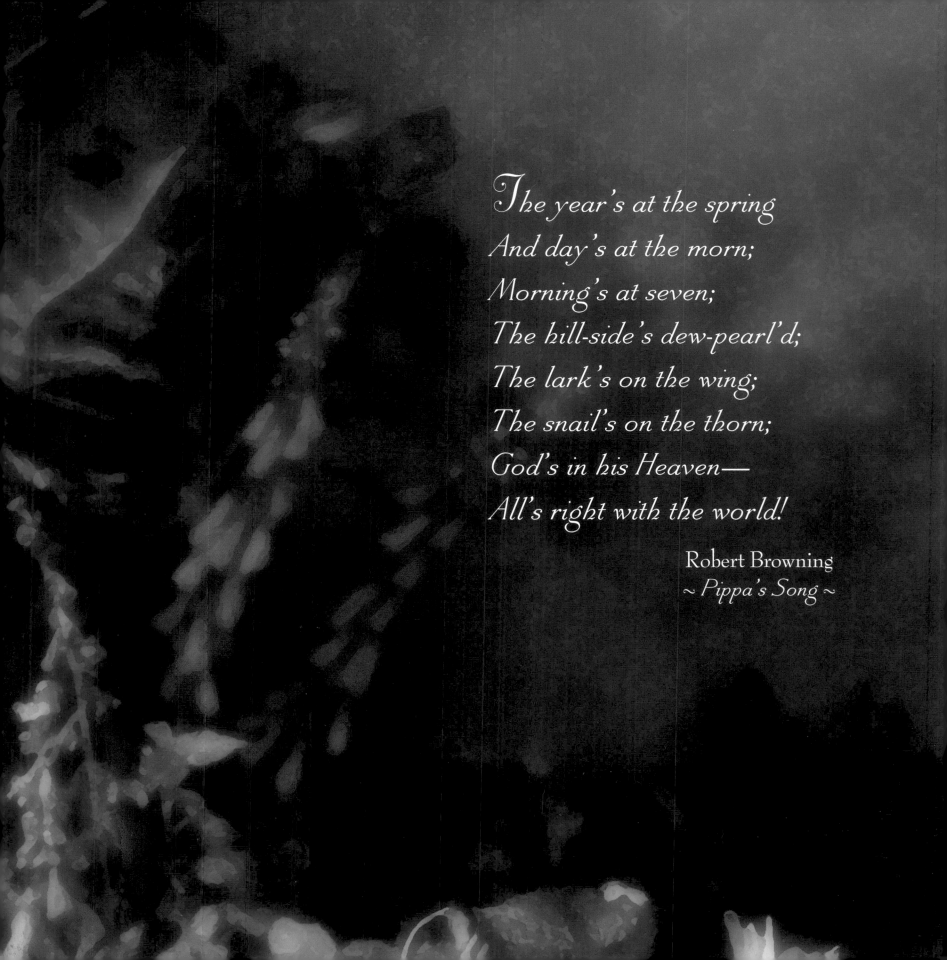

The year's at the spring
And day's at the morn;
Morning's at seven;
The hill-side's dew-pearl'd;
The lark's on the wing;
The snail's on the thorn;
God's in his Heaven—
All's right with the world!

Robert Browning
~ *Pippa's Song* ~

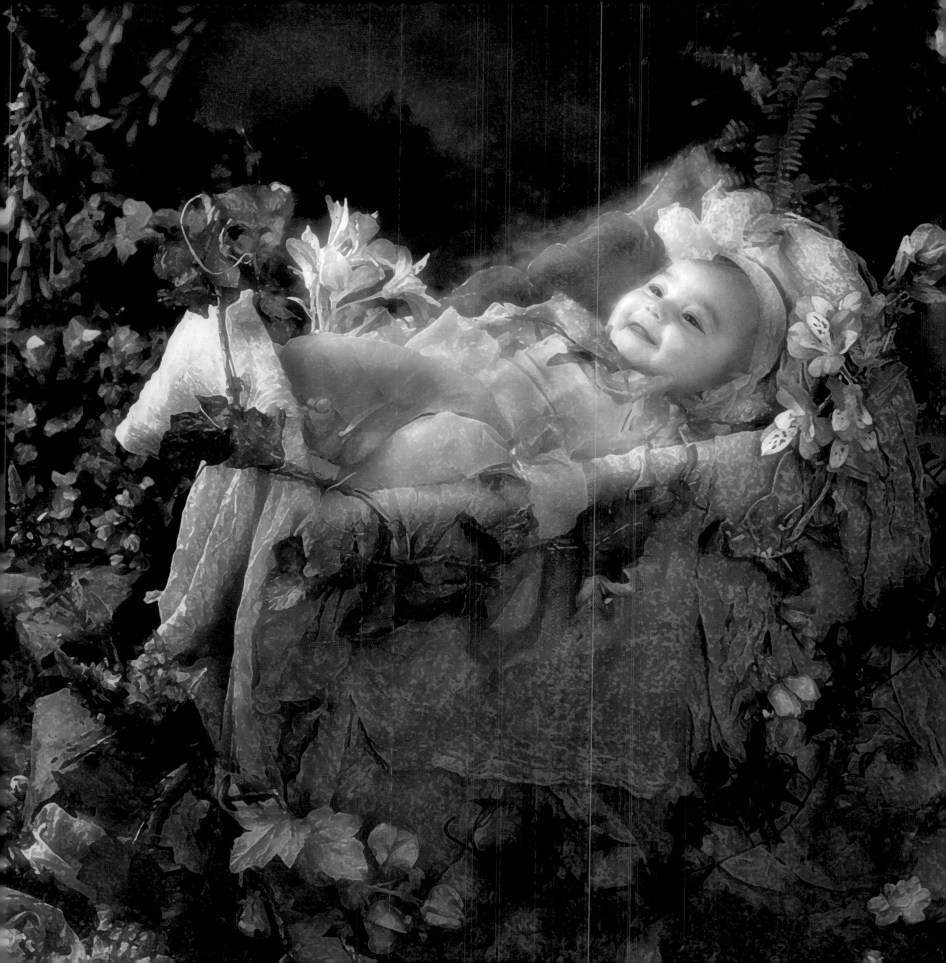

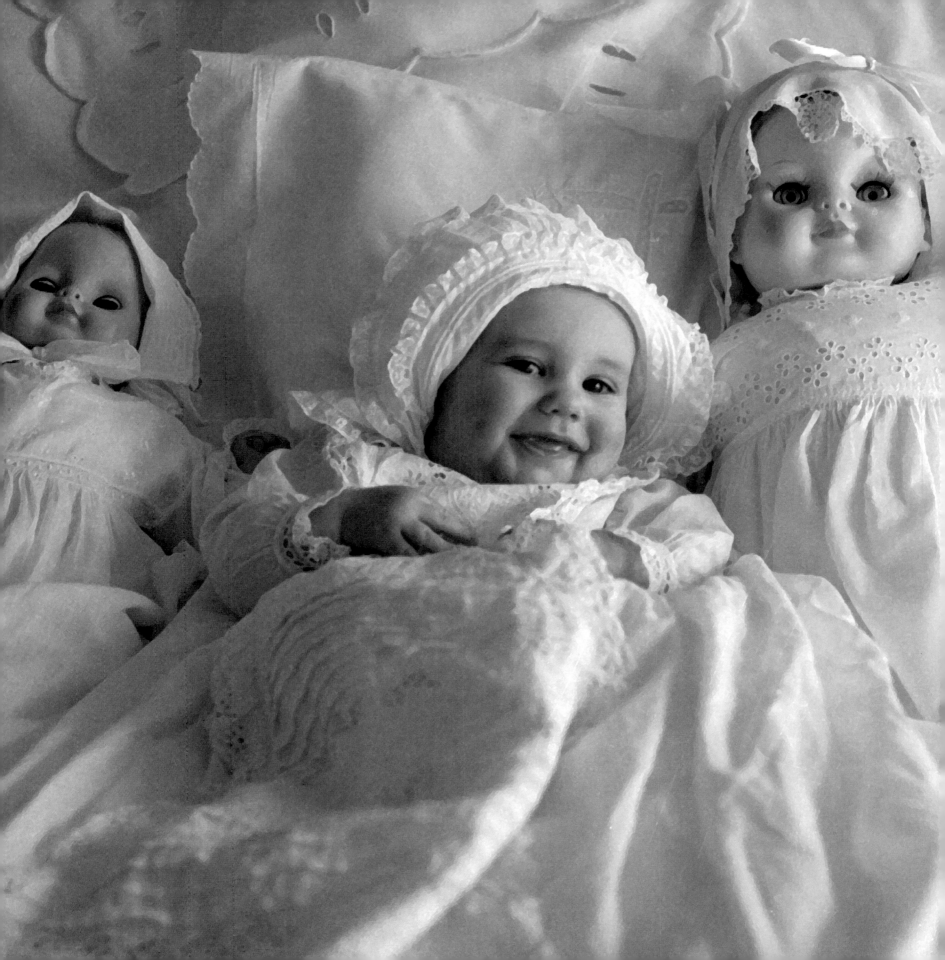

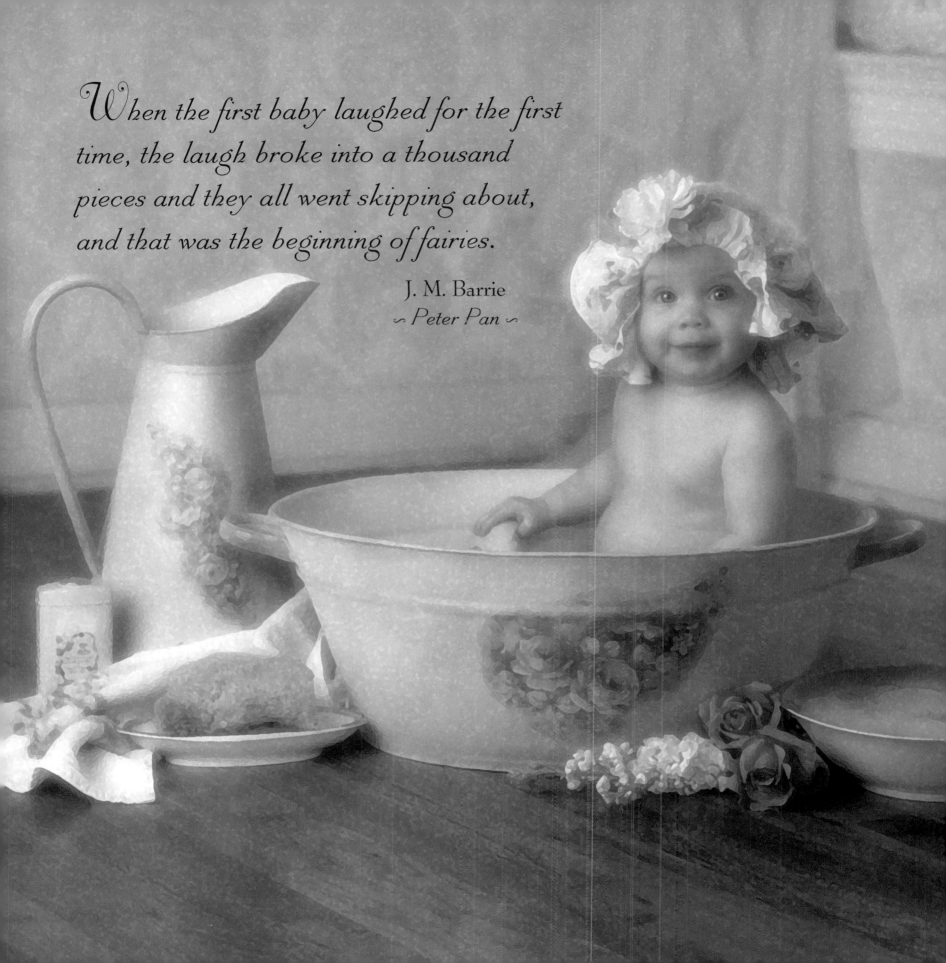

When the first baby laughed for the first time, the laugh broke into a thousand pieces and they all went skipping about, and that was the beginning of fairies.

J. M. Barrie
~ Peter Pan ~

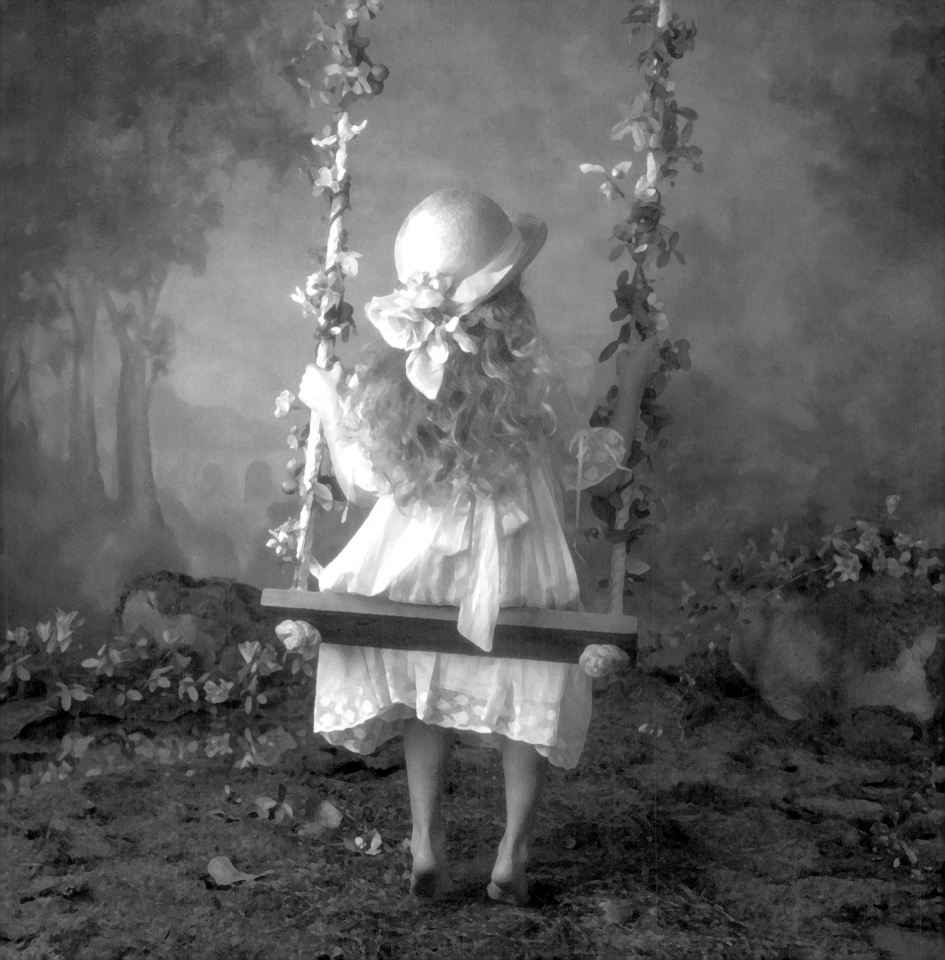

How do you like to go up in a swing,
 Up in the air so blue?
Oh, I do think it the pleasantest thing
 Ever a child can do!

Up in the air and over the walls,
 Till I can see so wide,
Rivers and trees and cattle and all
 Over the countryside—

Till I look down on the garden green,
 Down on the roof so brown—
Up in the air I go flying again,
 Up in the air and down!

Robert Louis Stevenson
~ The Swing ~

The world is so
full of a number
of things,
I'm sure we should
all be as happy as
kings.

Robert Louis Stevenson
~ Happy Thoughts ~

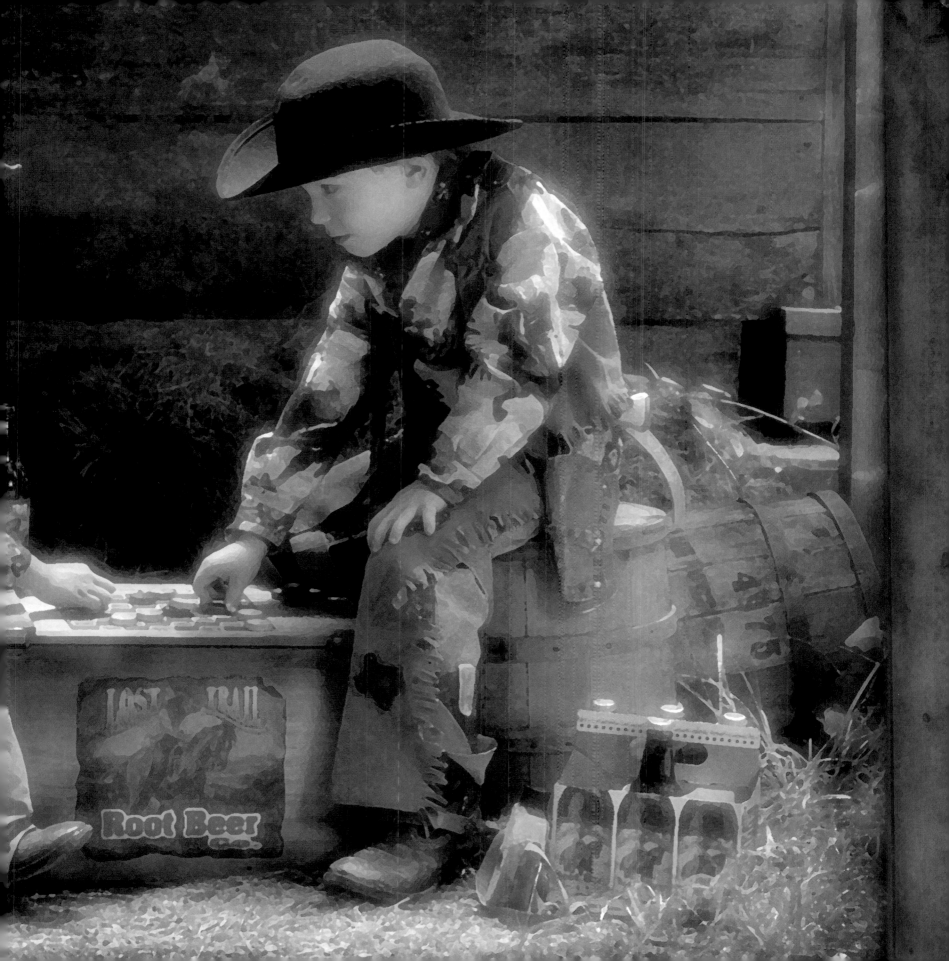

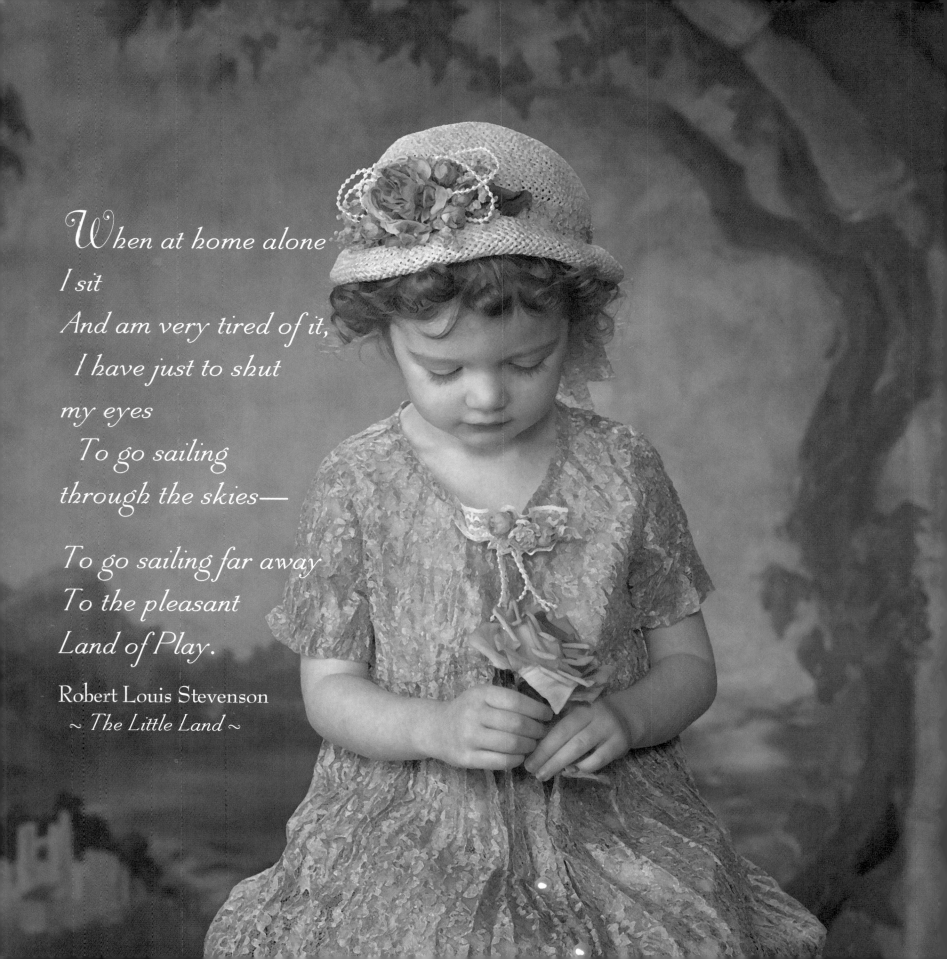

When at home alone
I sit
And am very tired of it,
I have just to shut
my eyes
To go sailing
through the skies—

To go sailing far away
To the pleasant
Land of Play.

Robert Louis Stevenson
~ *The Little Land* ~

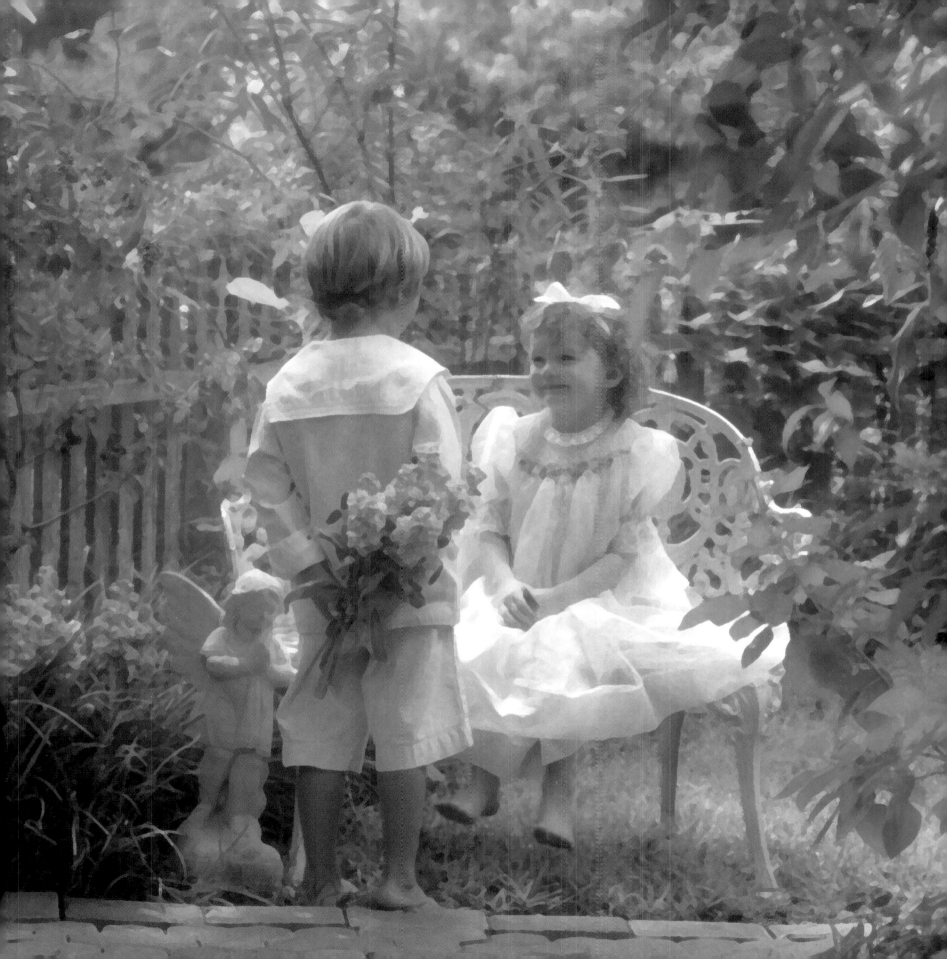

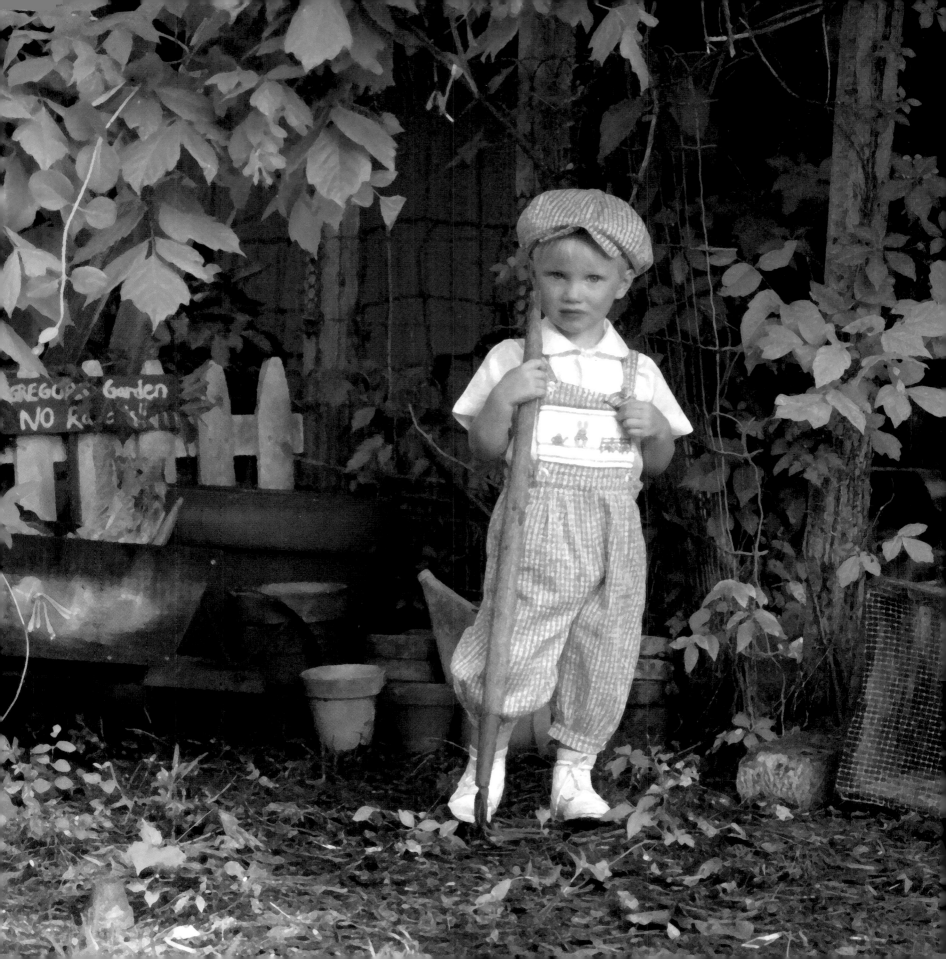

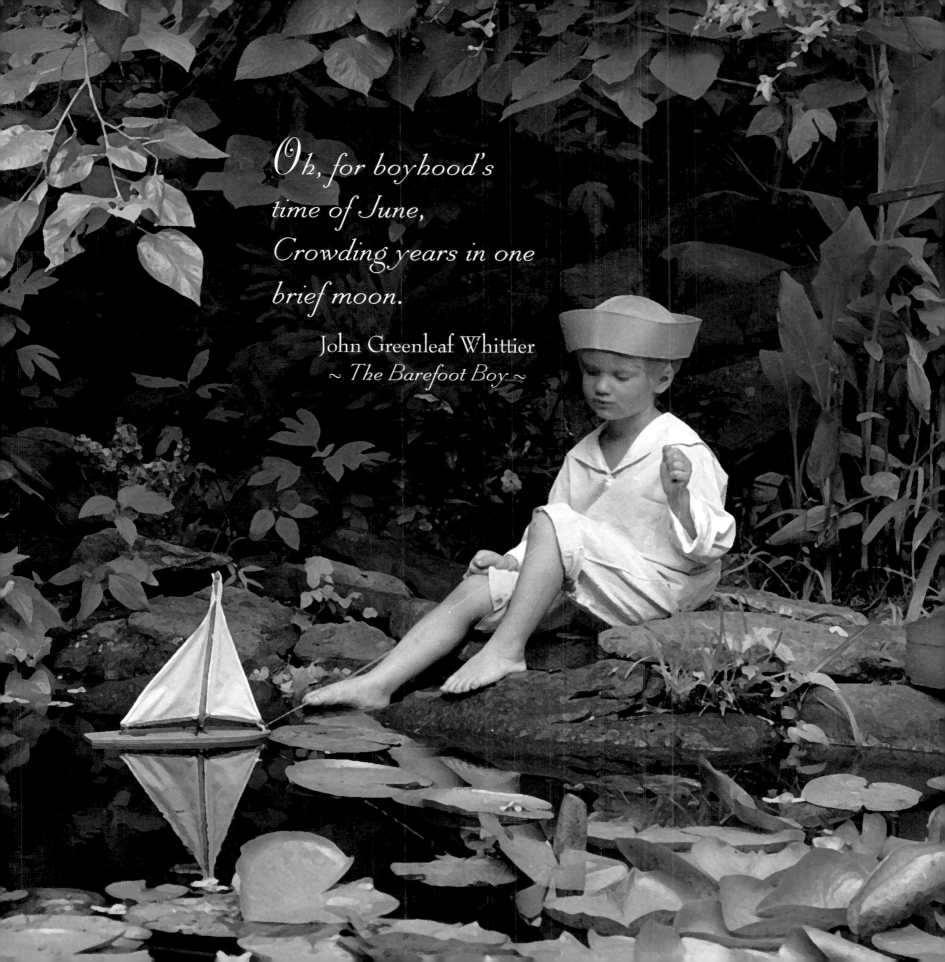

*Oh, for boyhood's
time of June,
Crowding years in one
brief moon.*

John Greenleaf Whittier
~ The Barefoot Boy ~

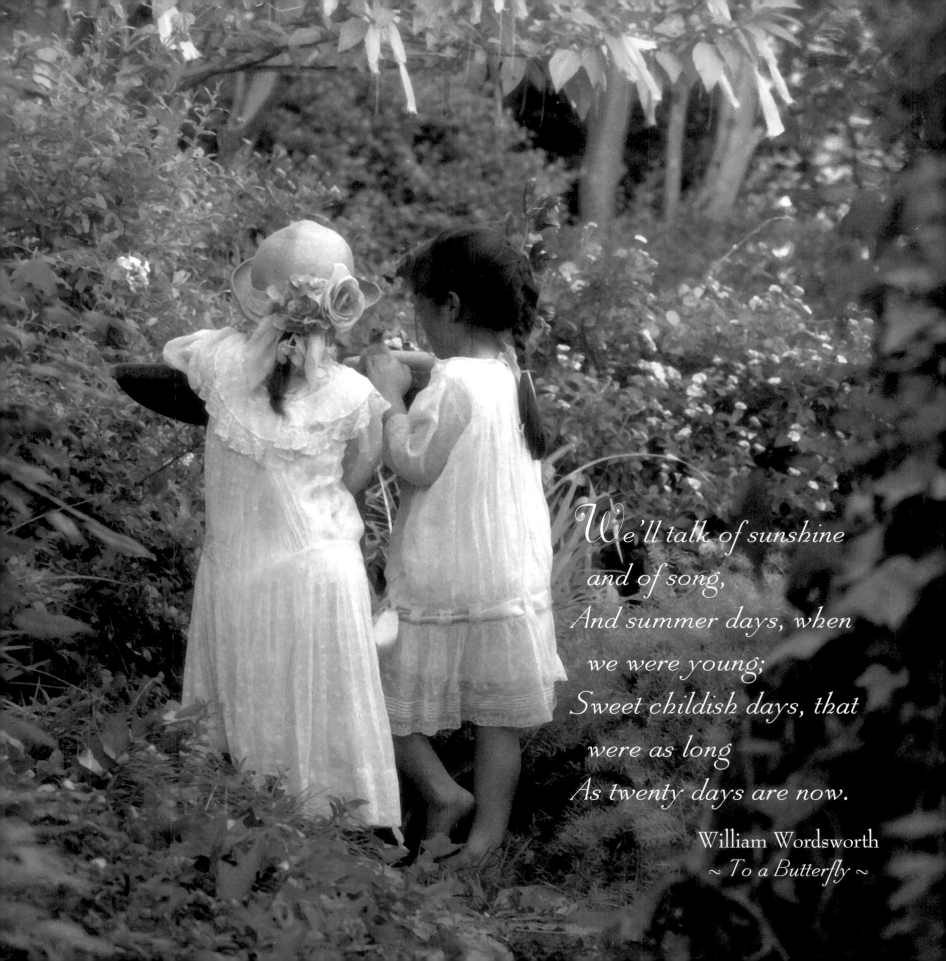

We'll talk of sunshine
and of song,
And summer days, when
we were young;
Sweet childish days, that
were as long
As twenty days are now.

William Wordsworth
~ To a Butterfly ~

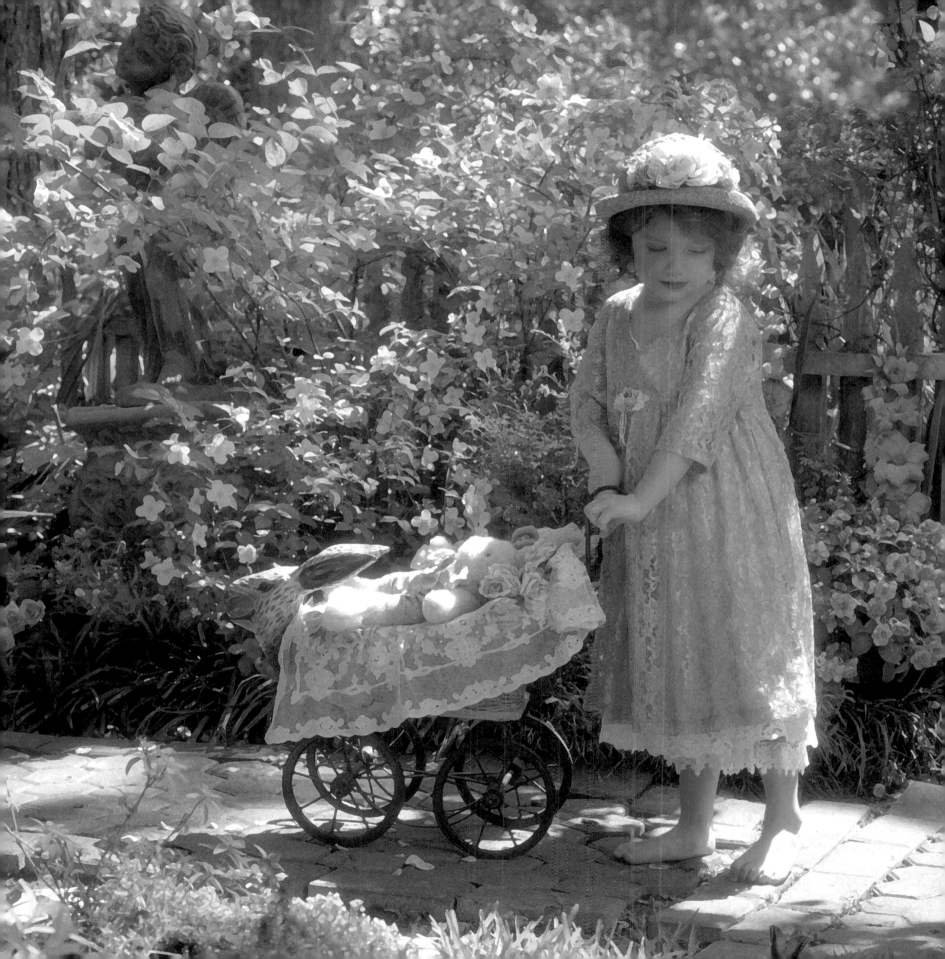

I never hankered for to plow or hoe,
And punching steers is all I know.
With my knees in the saddle and
 a-hanging to the sky,
Herding dogies up in heaven in the sweet
 by-and-by.

~ The Old Chisholm Trail ~

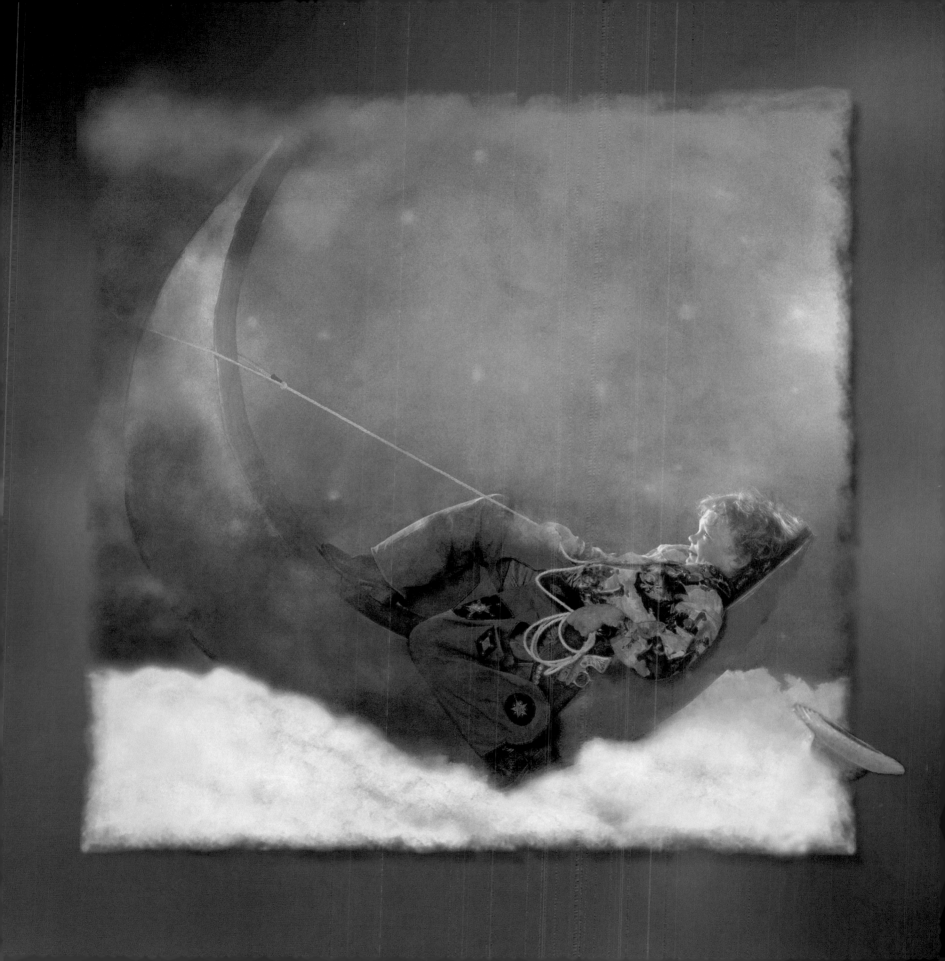

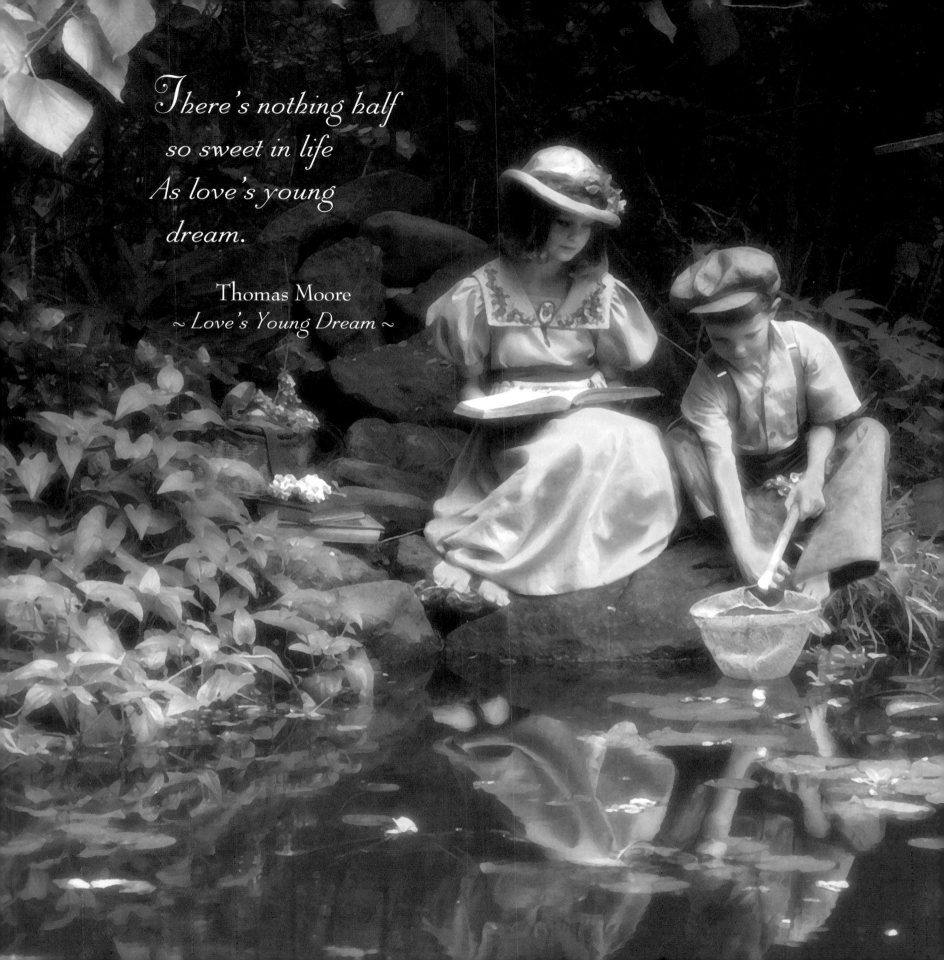

There's nothing half
so sweet in life
As love's young
dream.

Thomas Moore
~ Love's Young Dream ~

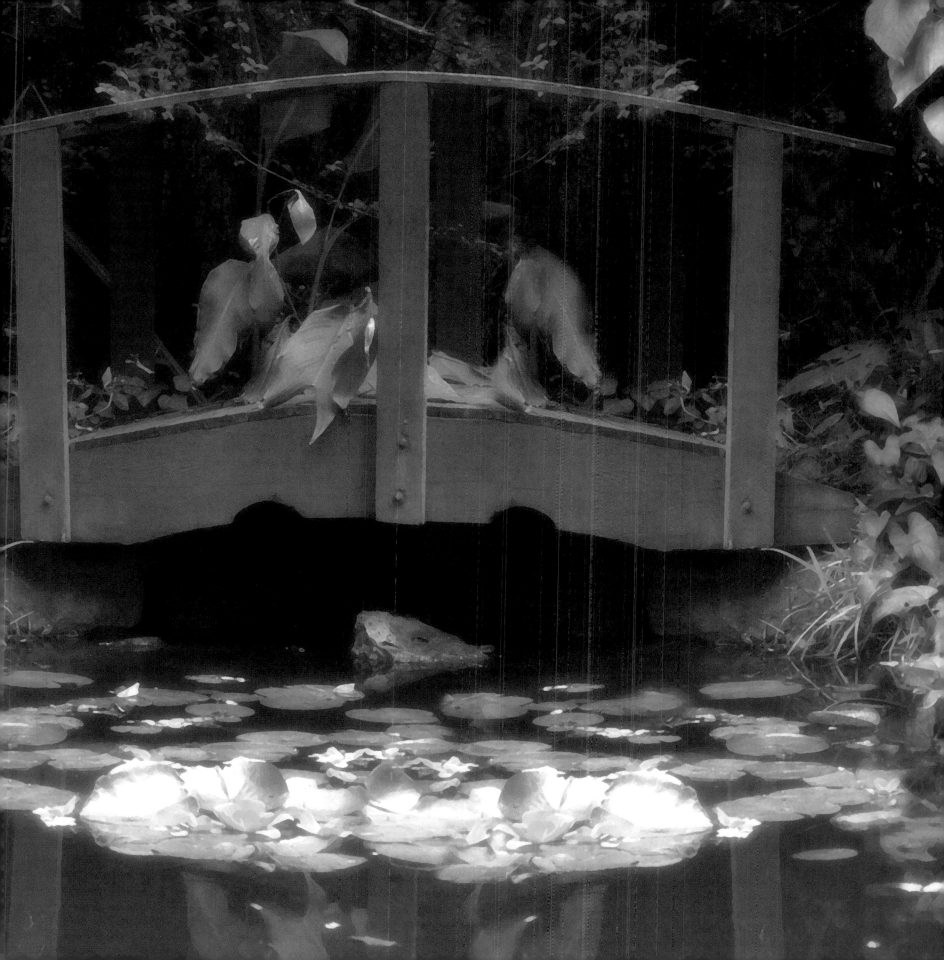

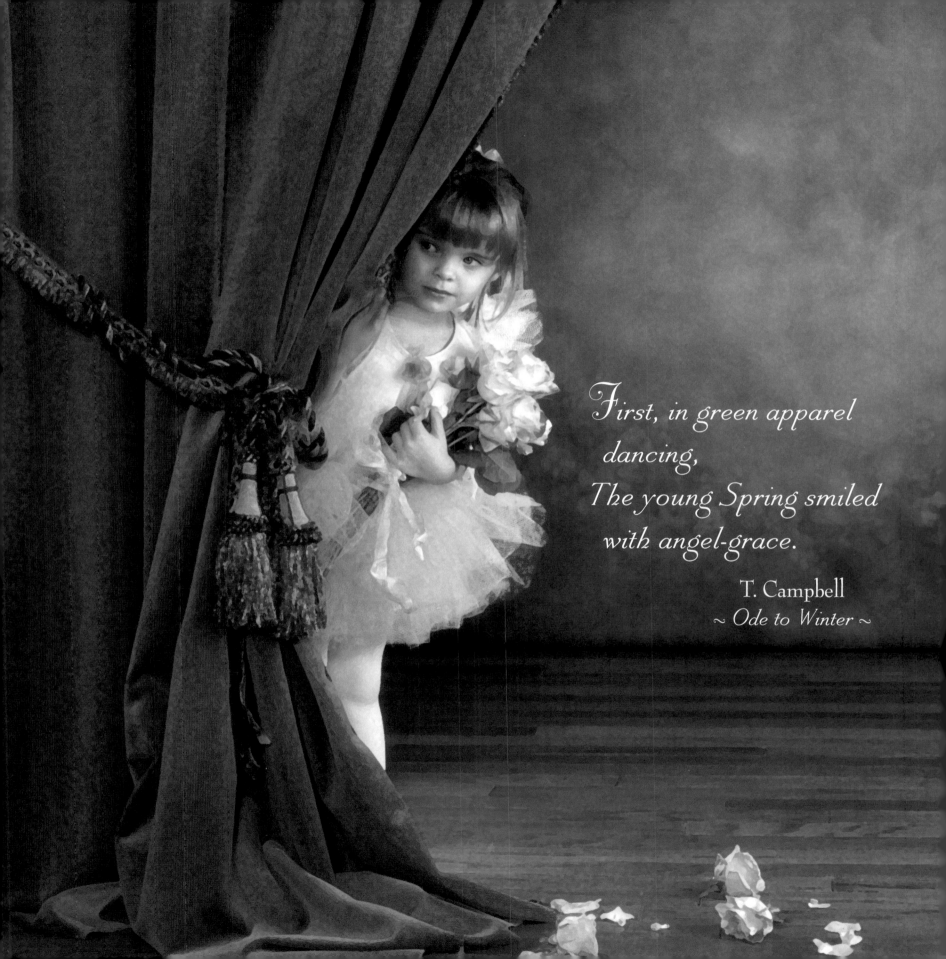

First, in green apparel
dancing,
The young Spring smiled
with angel-grace.

T. Campbell
~ Ode to Winter ~

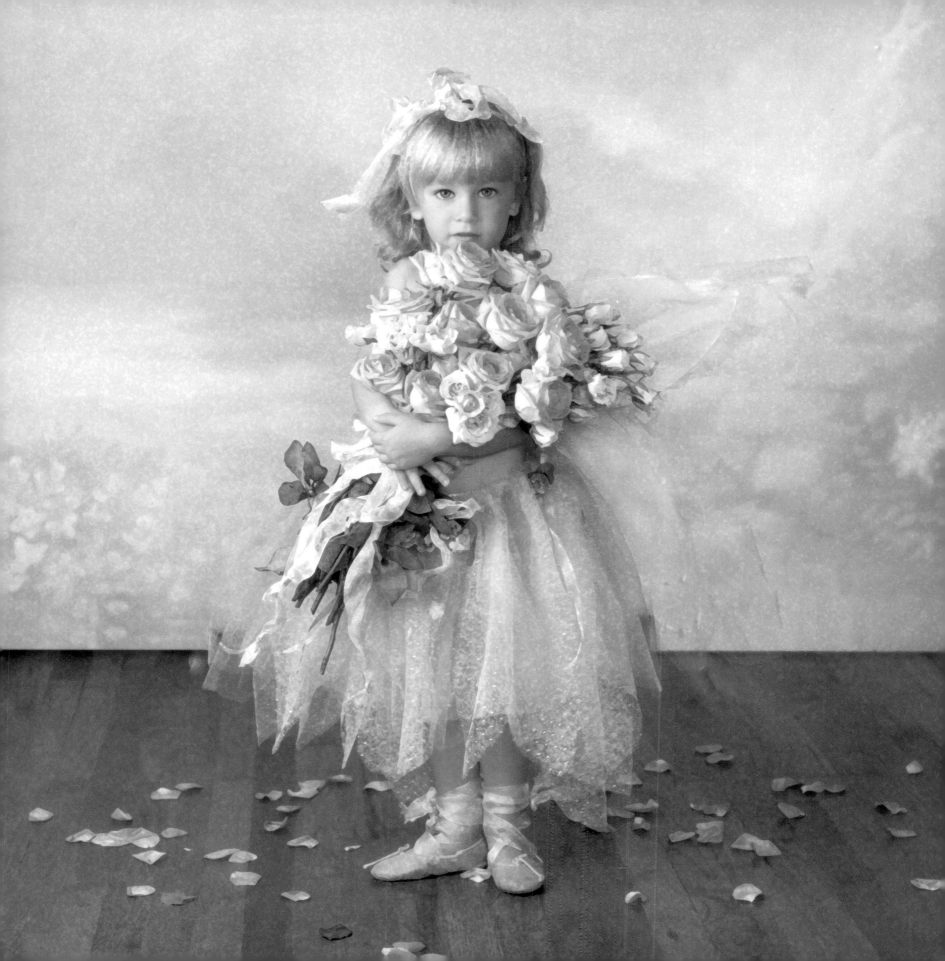

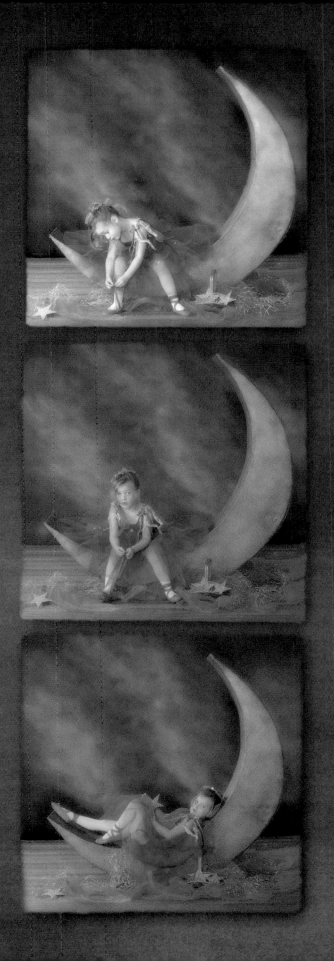

There was a star danced,
and under that was I born.

William Shakespeare
~ *Much Ado About Nothing* ~

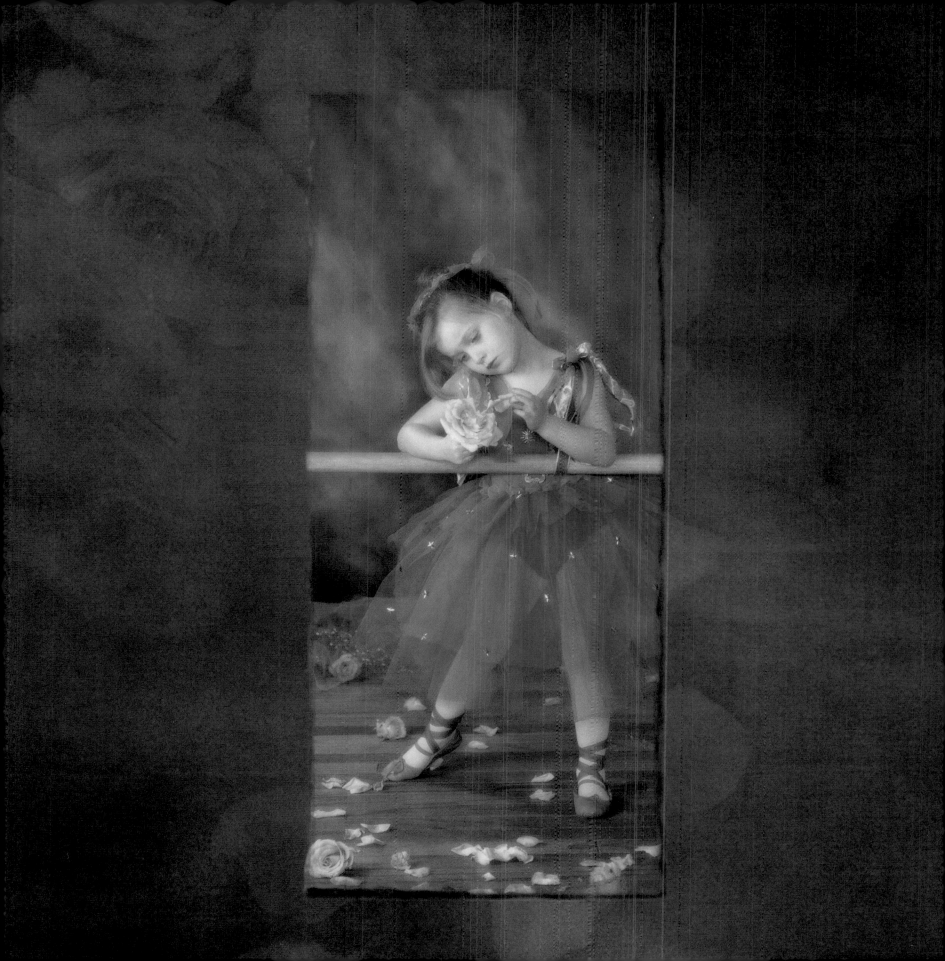

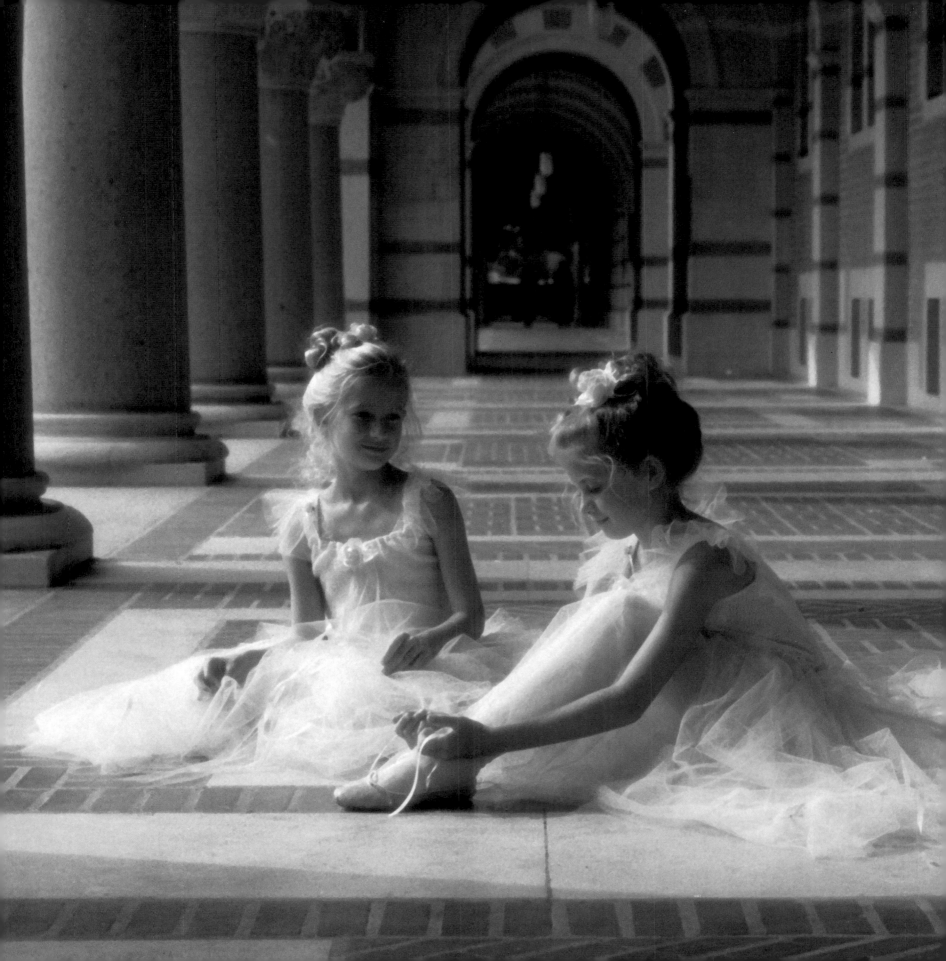

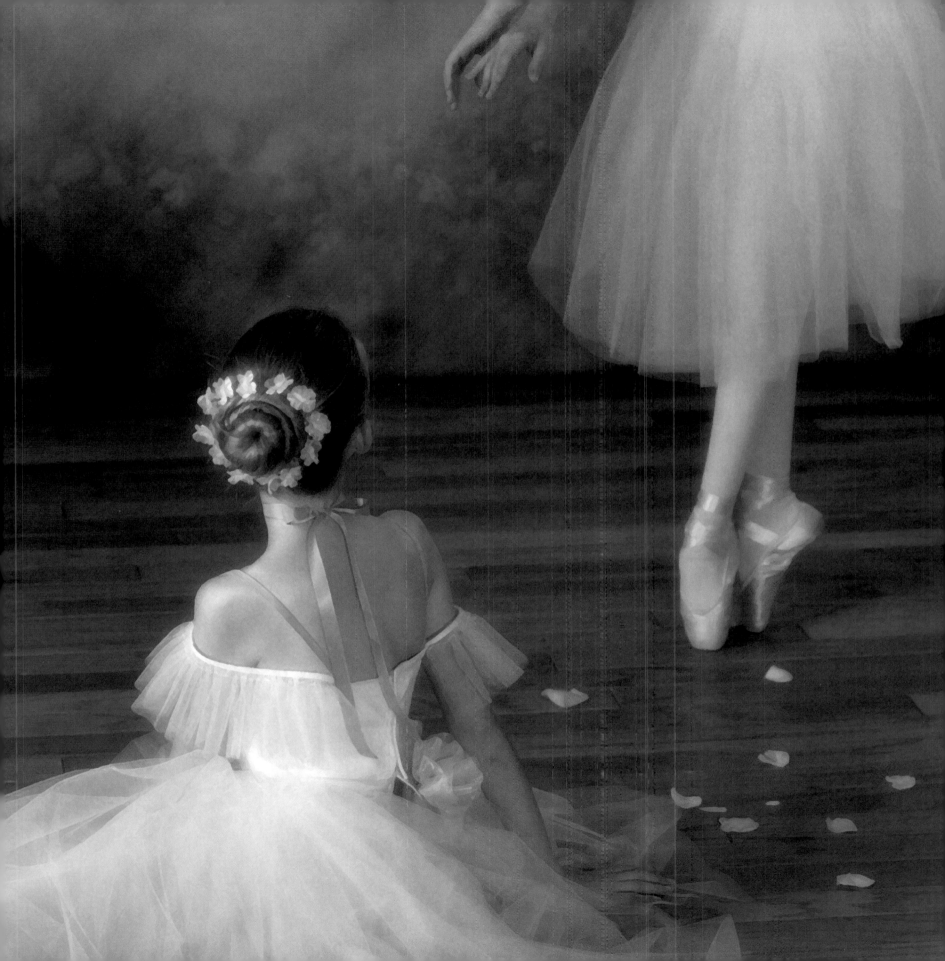

Once Upon
a Time

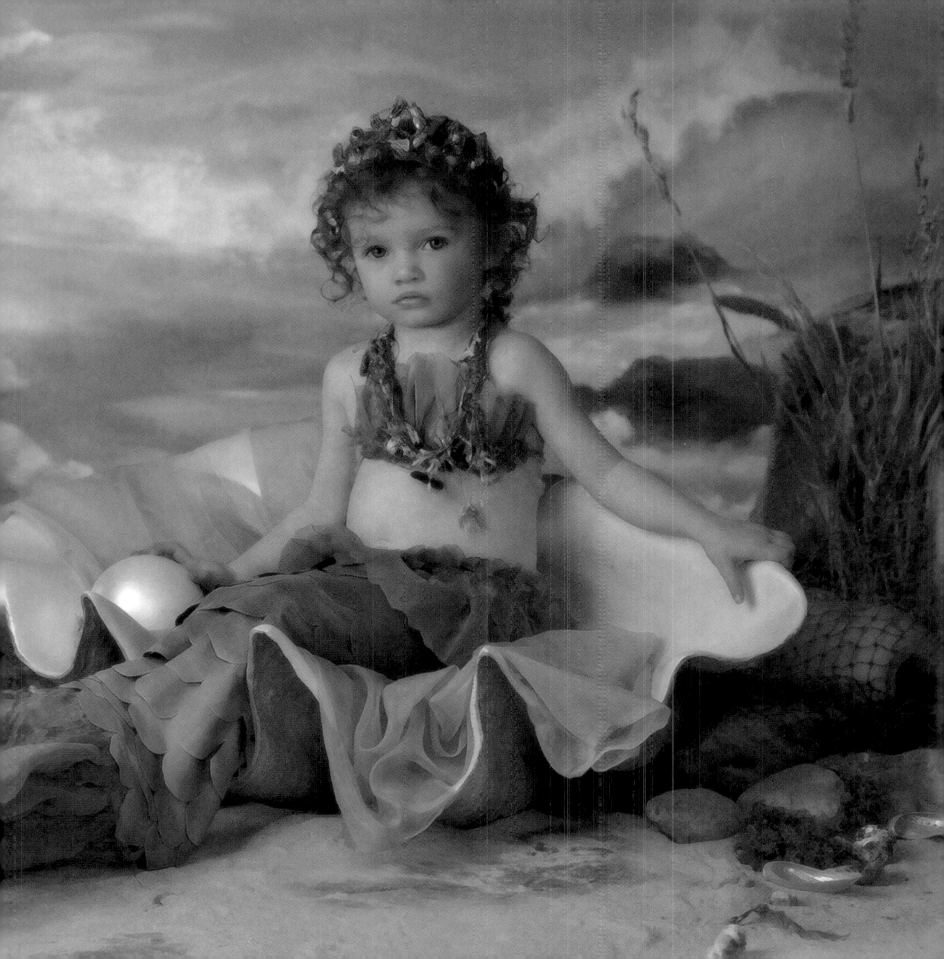

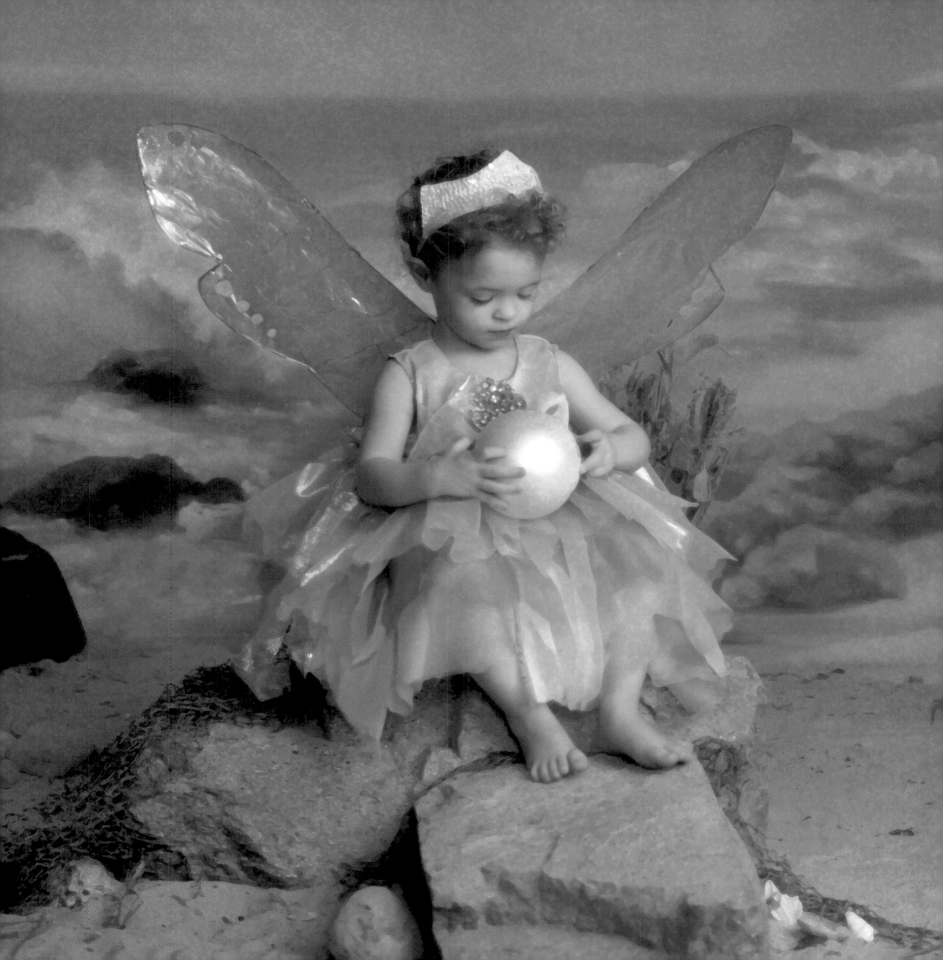

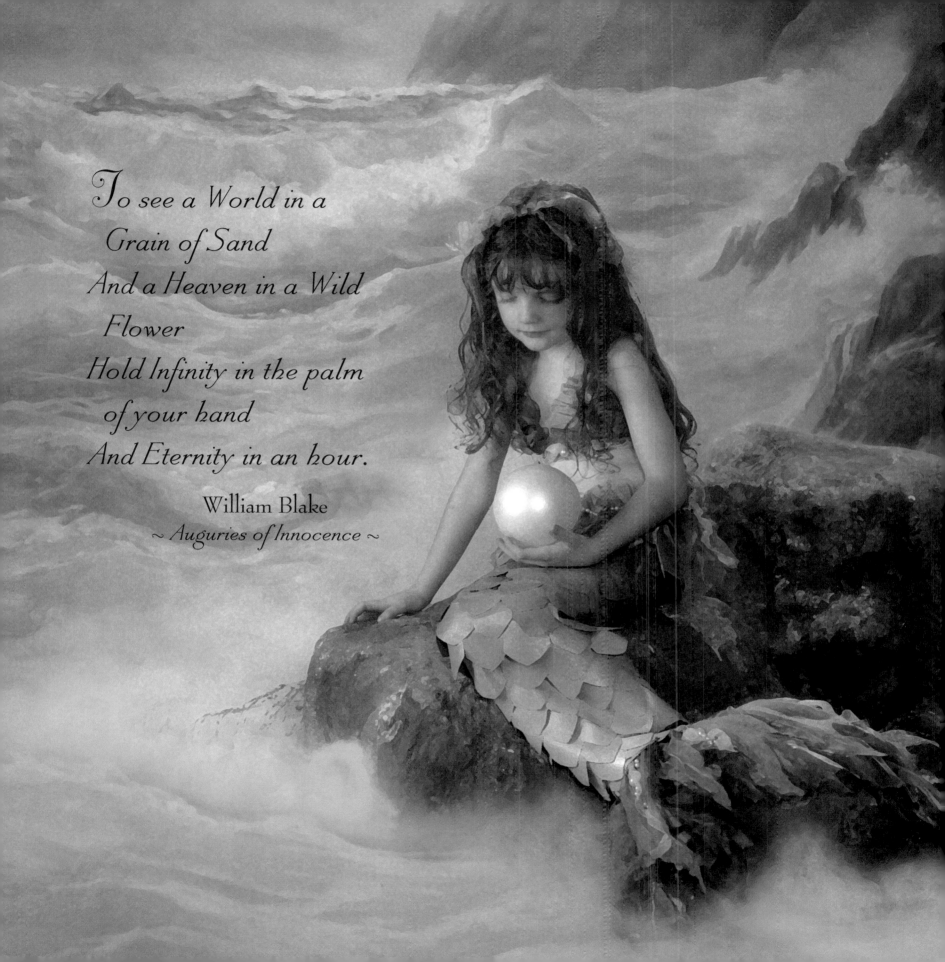

To see a World in a
Grain of Sand
And a Heaven in a Wild
Flower
Hold Infinity in the palm
of your hand
And Eternity in an hour.

William Blake
~ Auguries of Innocence ~

Azure-blue eyes, in a marvel of wonder,
 Over the dawn of a blush breaking out;
Sensitive nose, with a little smile under
 Trying to hide in a blossoming pout—
Couldn't be serious, try as you would,
 Little mysterious Red Riding-Hood!

<div align="right">James Whitcomb Riley
~ Little Red Riding-Hood ~</div>

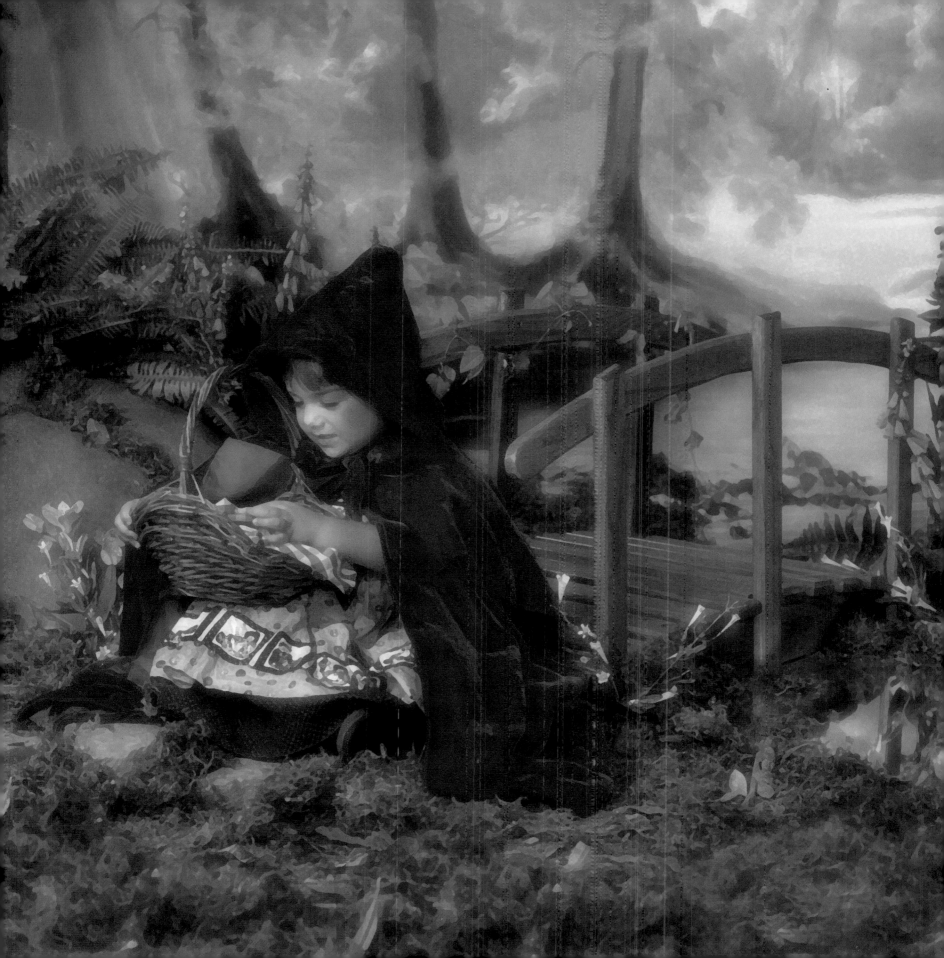

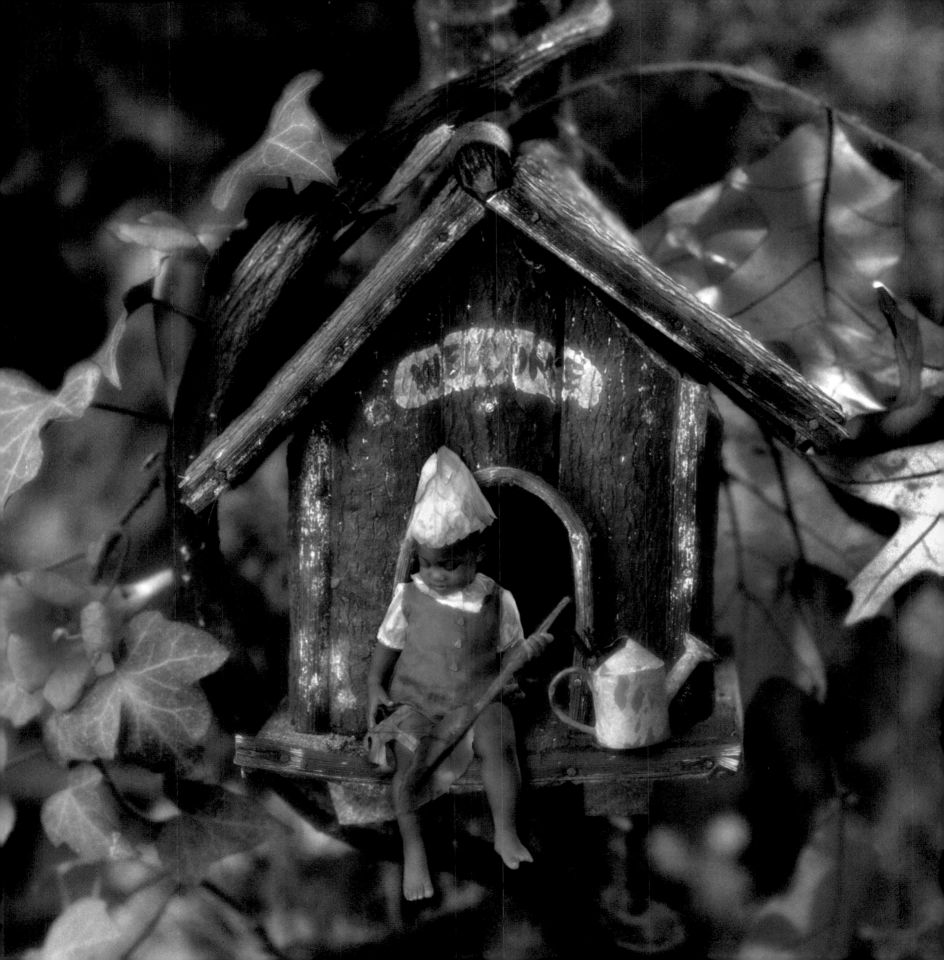

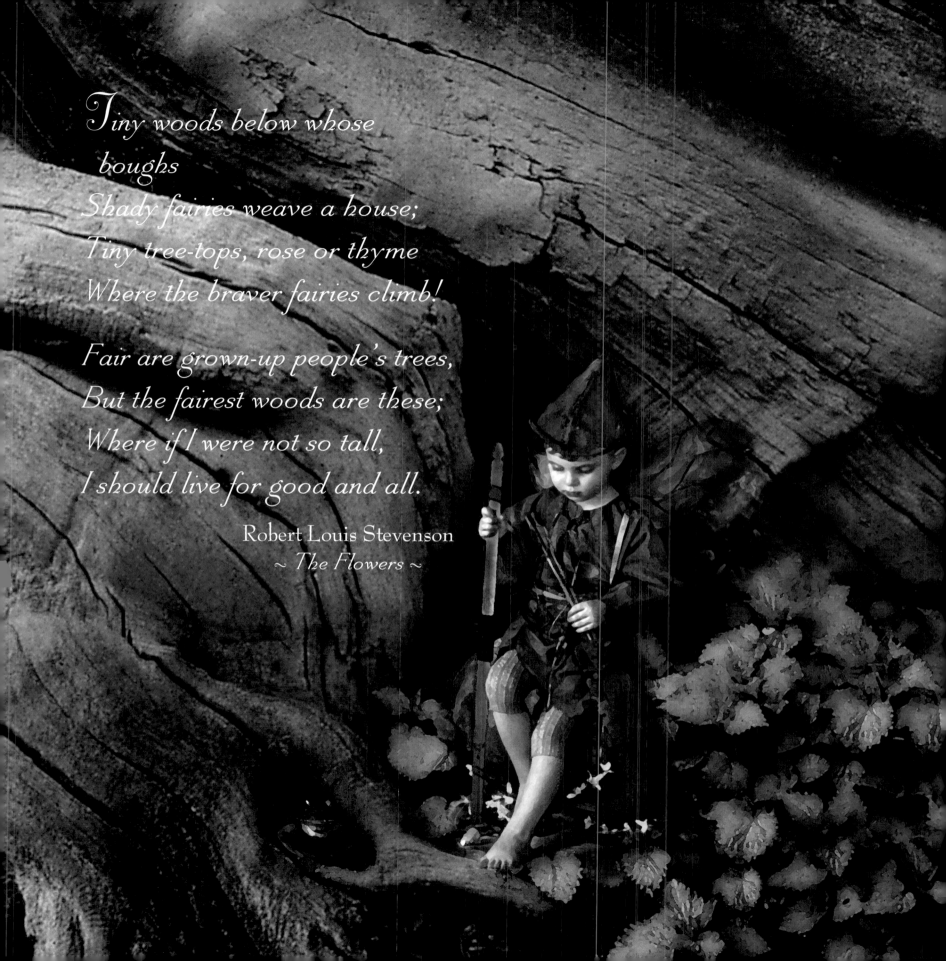

Tiny woods below whose
 boughs
Shady fairies weave a house;
Tiny tree-tops, rose or thyme
Where the braver fairies climb!

Fair are grown-up people's trees,
But the fairest woods are these;
Where if I were not so tall,
I should live for good and all.

Robert Louis Stevenson
~ The Flowers ~

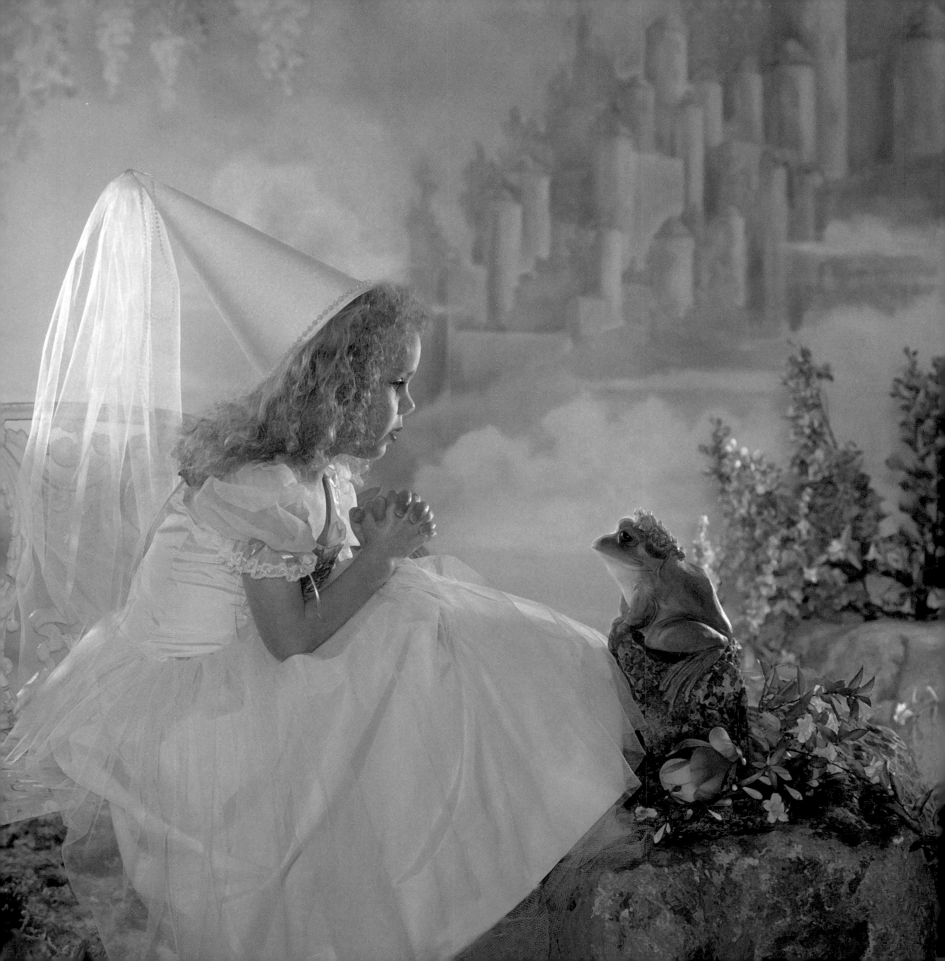

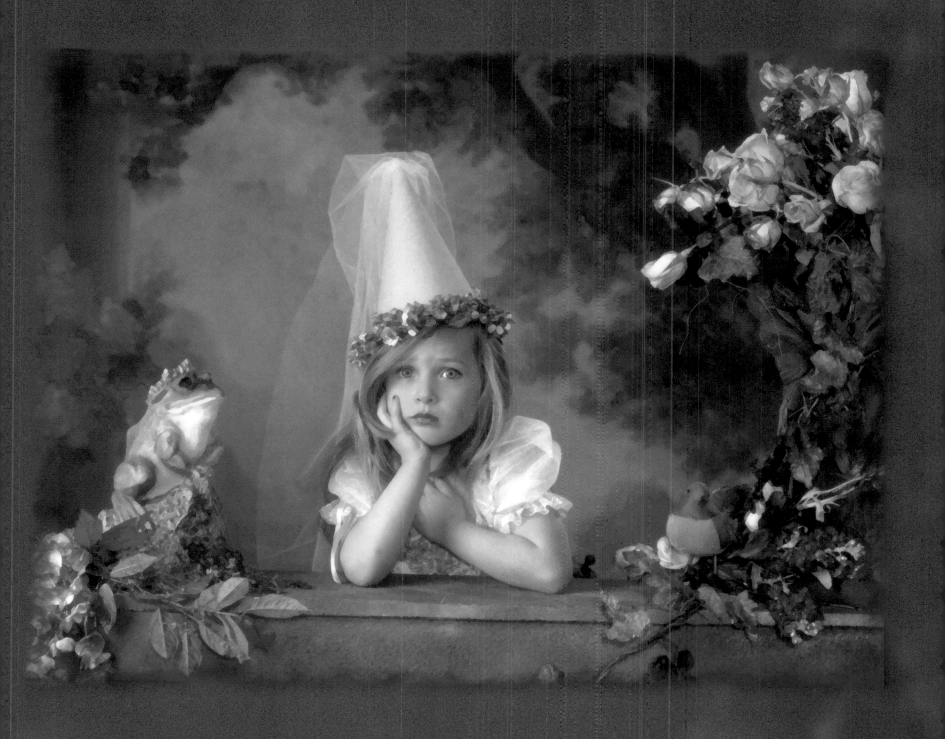

"It's true," she said. "Sometimes I do pretend I am a princess. I
pretend I am a princess, so that I can try and behave like one."

Frances Hodgson Burnett
~ *A Little Princess* ~

At seven, when I go to bed, I find
such pictures in my head:
Castles with dragons prowling round,
Gardens where magic fruits are
 found;
Fair ladies prisoned in a tower,
Or lost in an enchanted bower;
While gallant horsemen ride by
 streams
That border all this land of dreams
I find, so clearly in my head
At seven, when I go to bed.

Robert Louis Stevenson
~ A Child's Thought ~

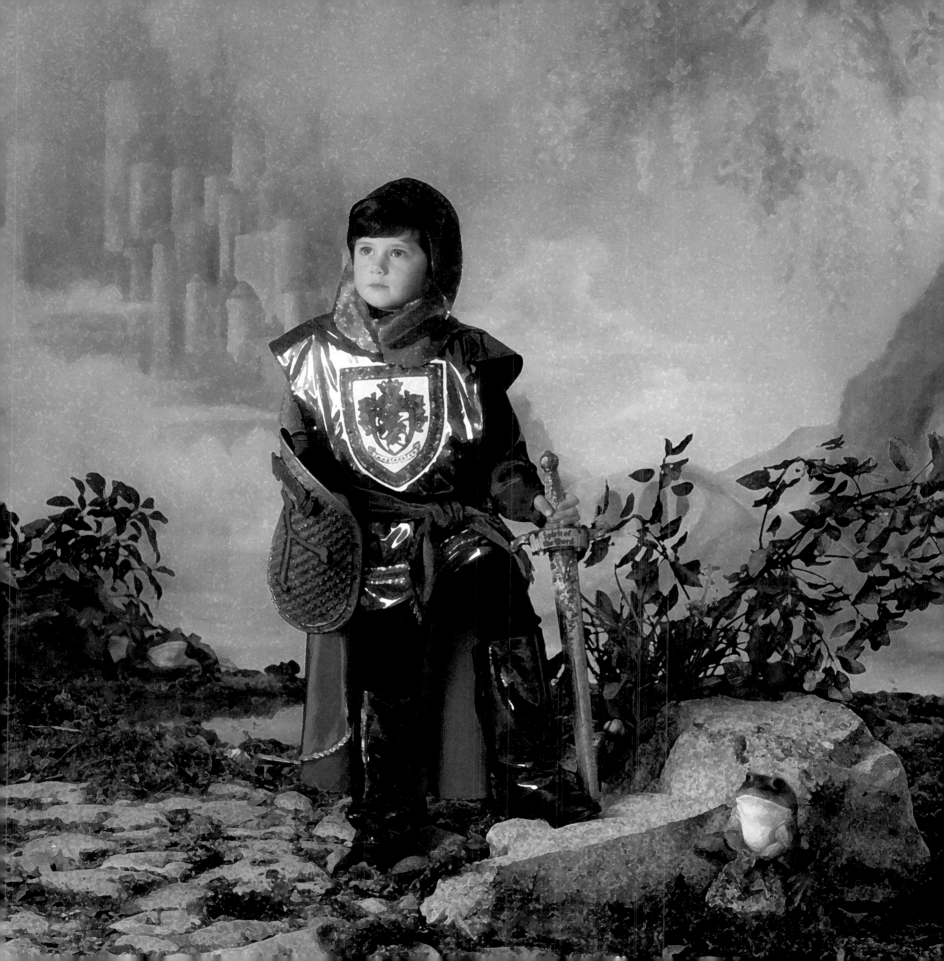

*There is sweet music here that softer falls
Than petals from blown roses on the grass. . . .
Music that gentlier on the spirit lies,
Than tired eyelids upon tired eyes;
Music that brings sweet sleep down from the blissful skies.*

Alfred, Lord Tennyson
~ The Lotos-Eaters ~

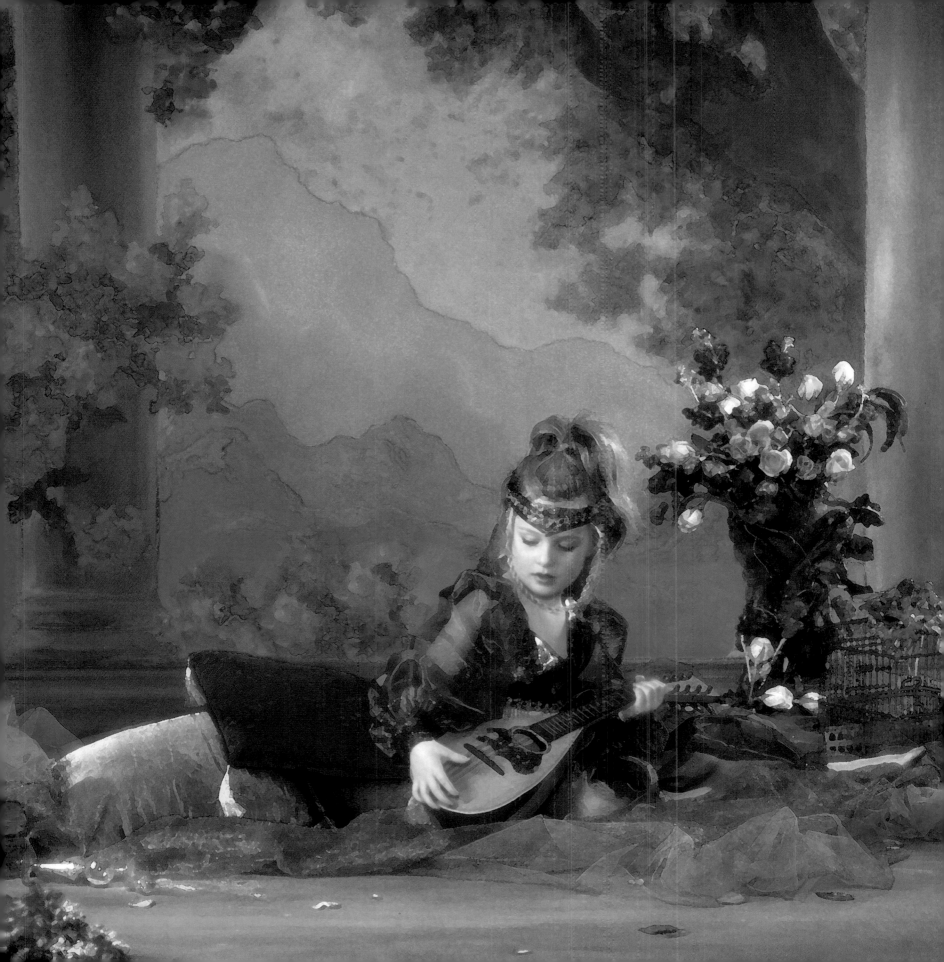

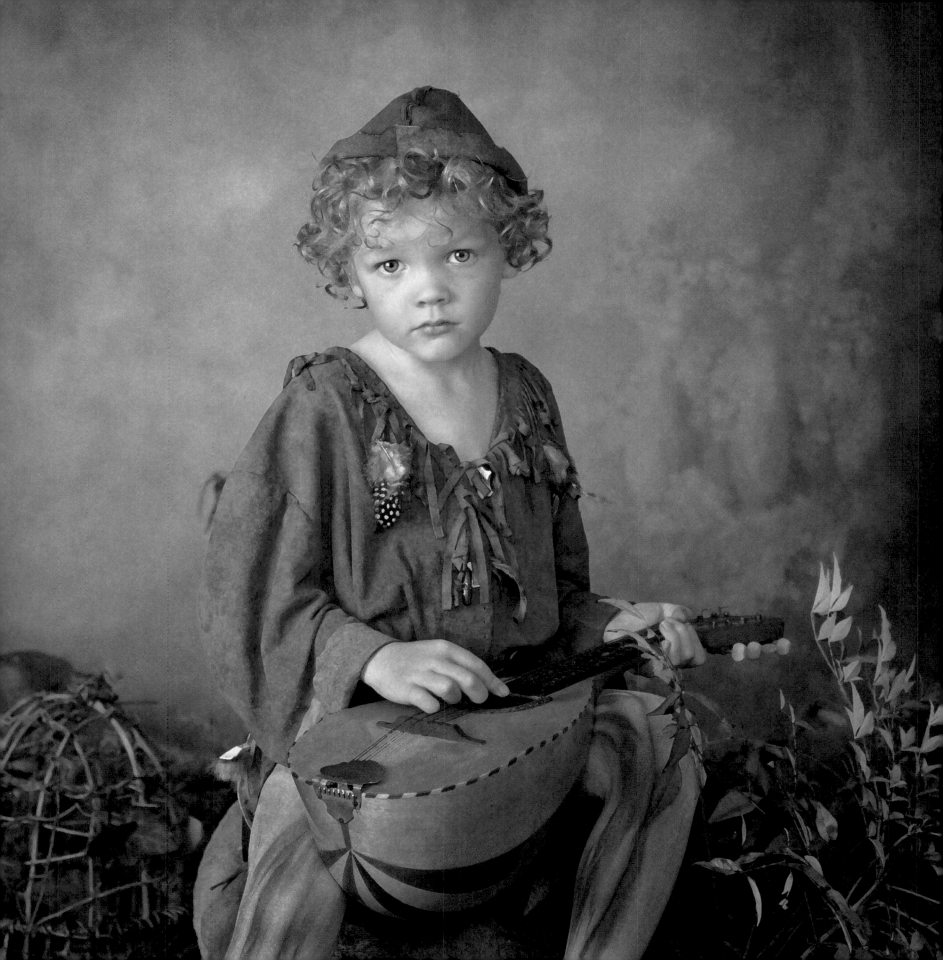

In peace, Love tunes the shepherd's reed;
In war, he mounts the warrior's steed;
In halls, in gay attire is seen;
In hamlets, dances on the green.
Love rules the court, the camp, the grove,
And men below, and saints above;
For love is heaven, and heaven is love.

Sir Walter Scott
~ The Lay of the Last Minstrel ~

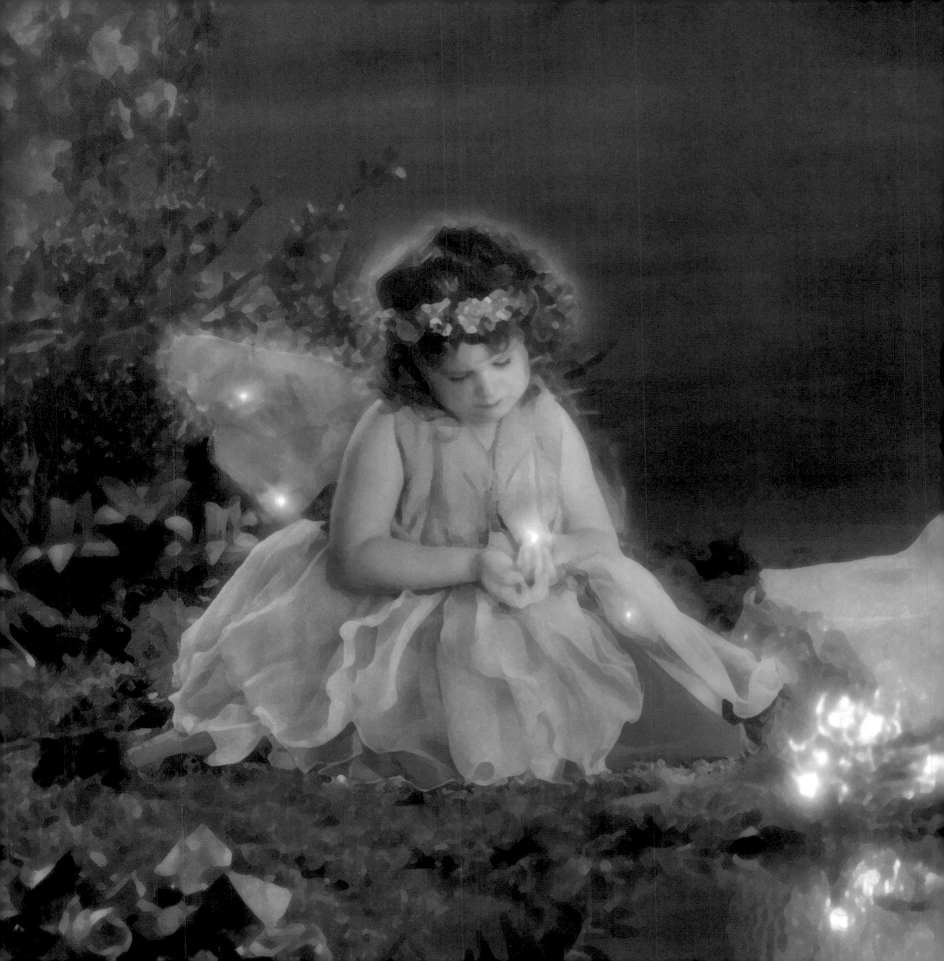

The Secret
Fairy Garden

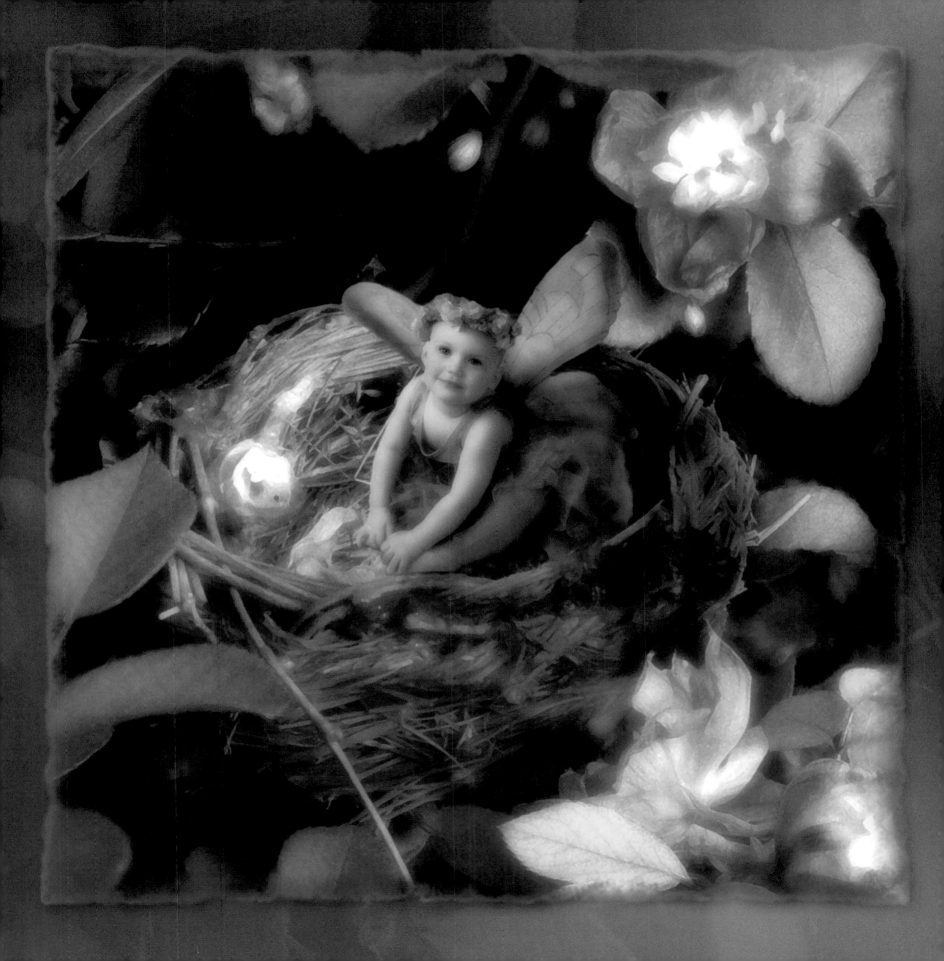

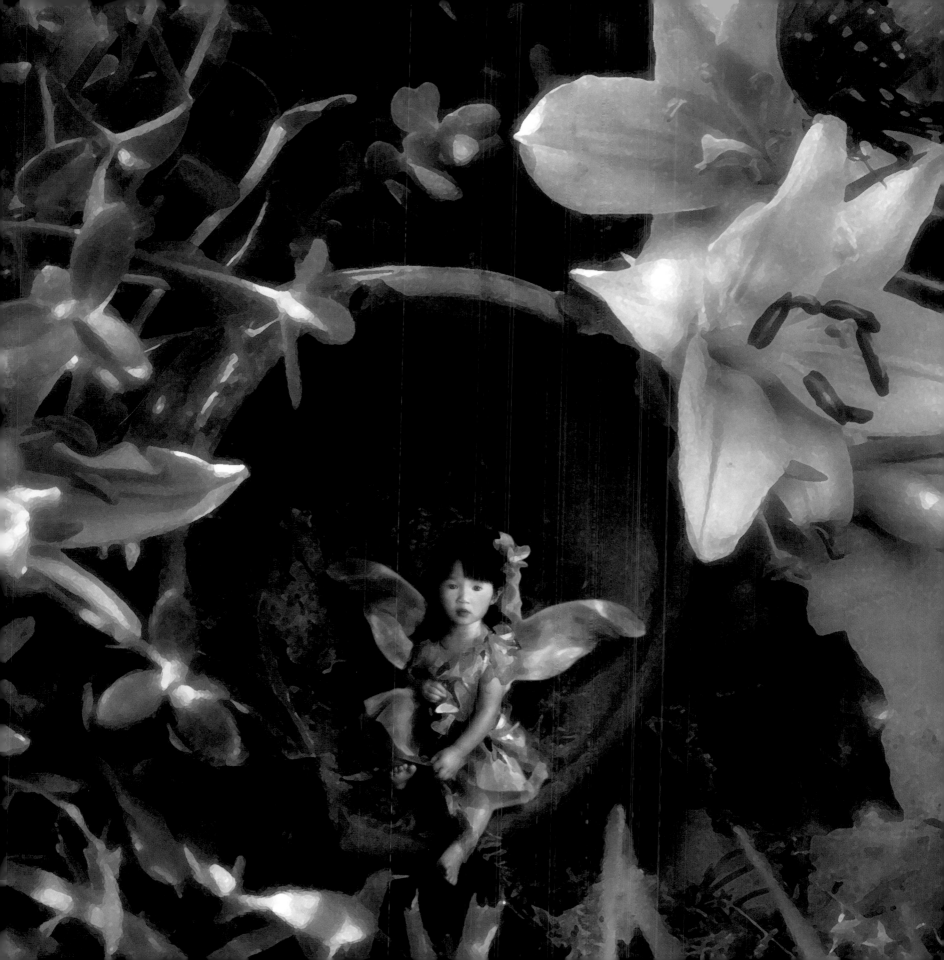

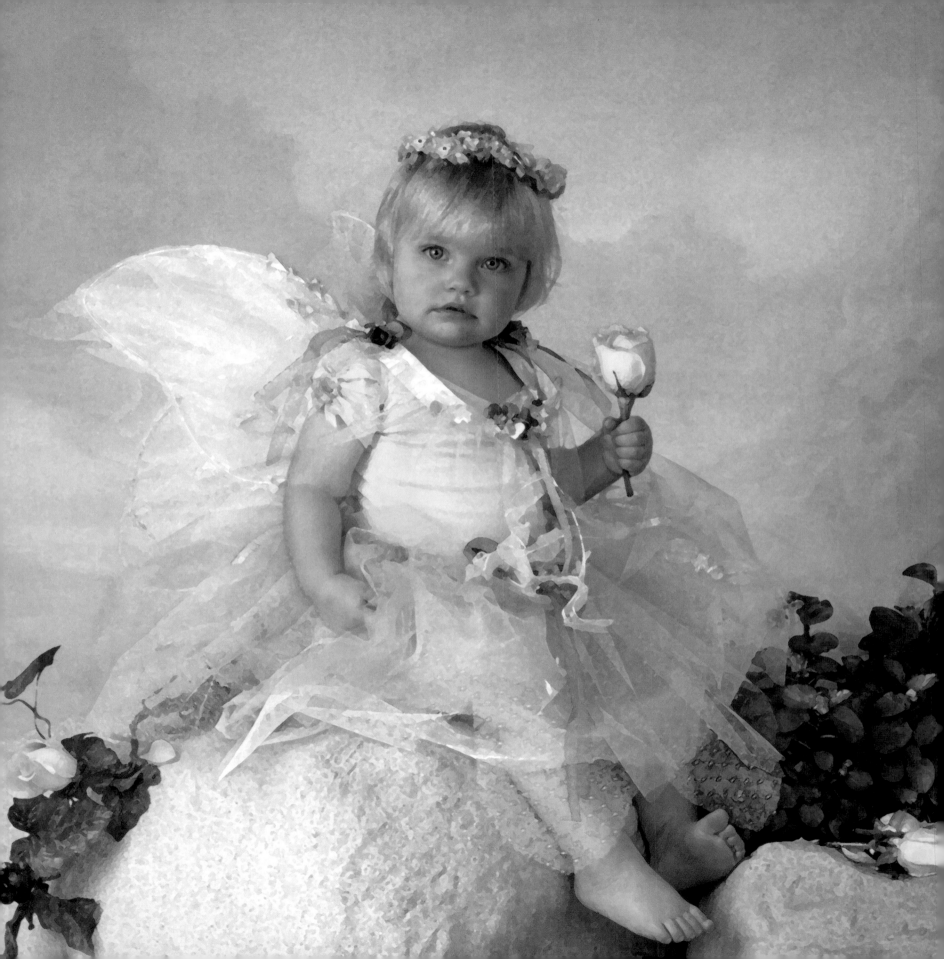

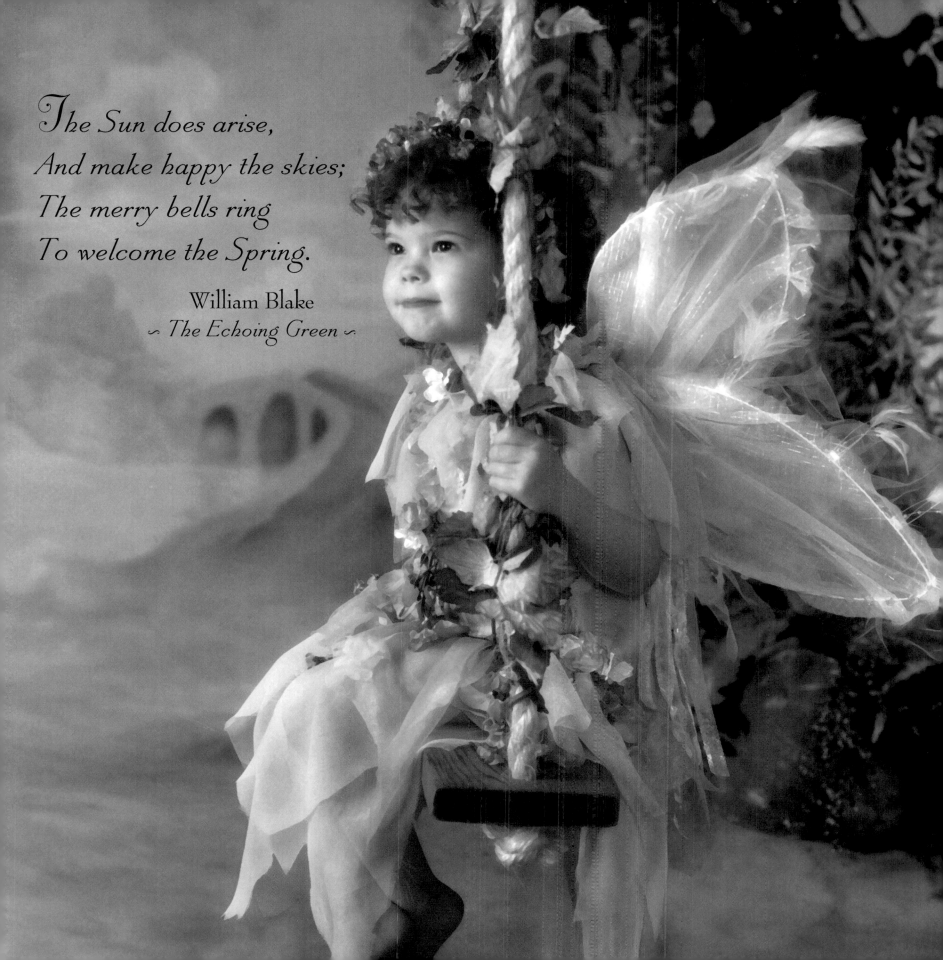

The Sun does arise,
And make happy the skies;
The merry bells ring
To welcome the Spring.

William Blake
~ *The Echoing Green* ~

Elf-light, bat-light,
Touchwood-light and toad-light,
And the sea a shimmering gloom of grey,
And a small face smiling
In a dream's beguiling
In a world of wonders far away.

Walter de la Mare
~ *Dream-Song* ~

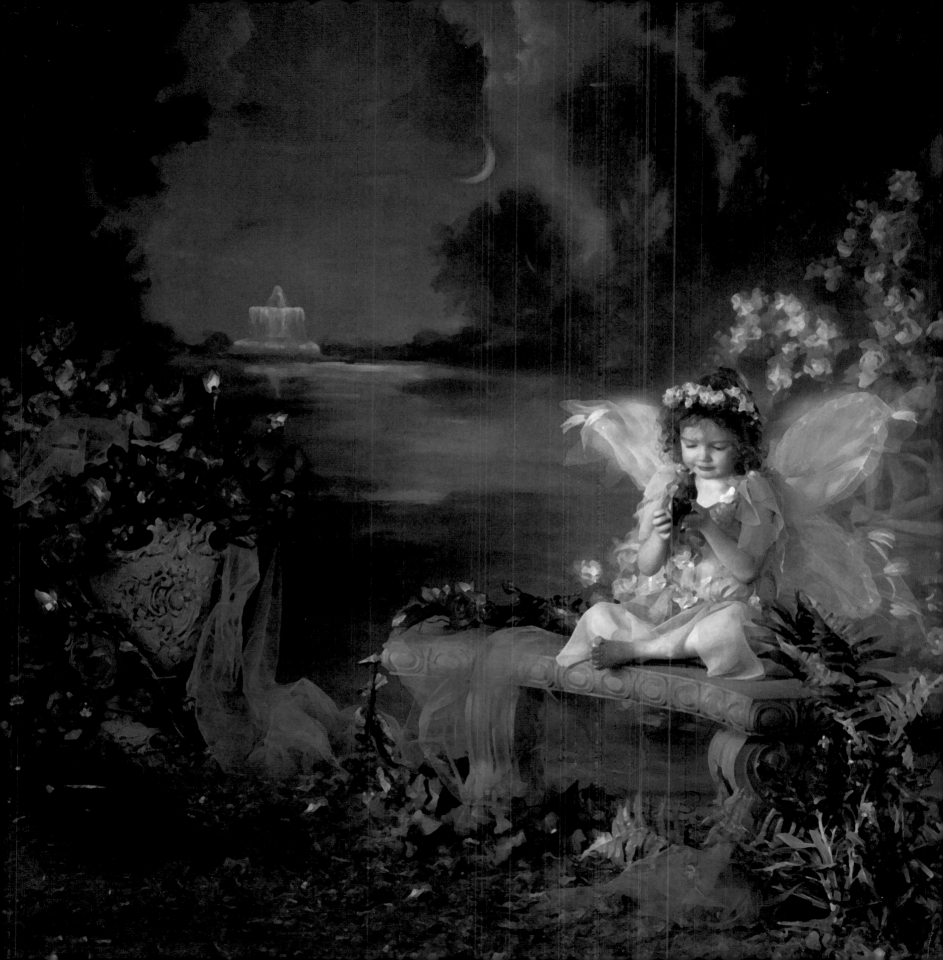

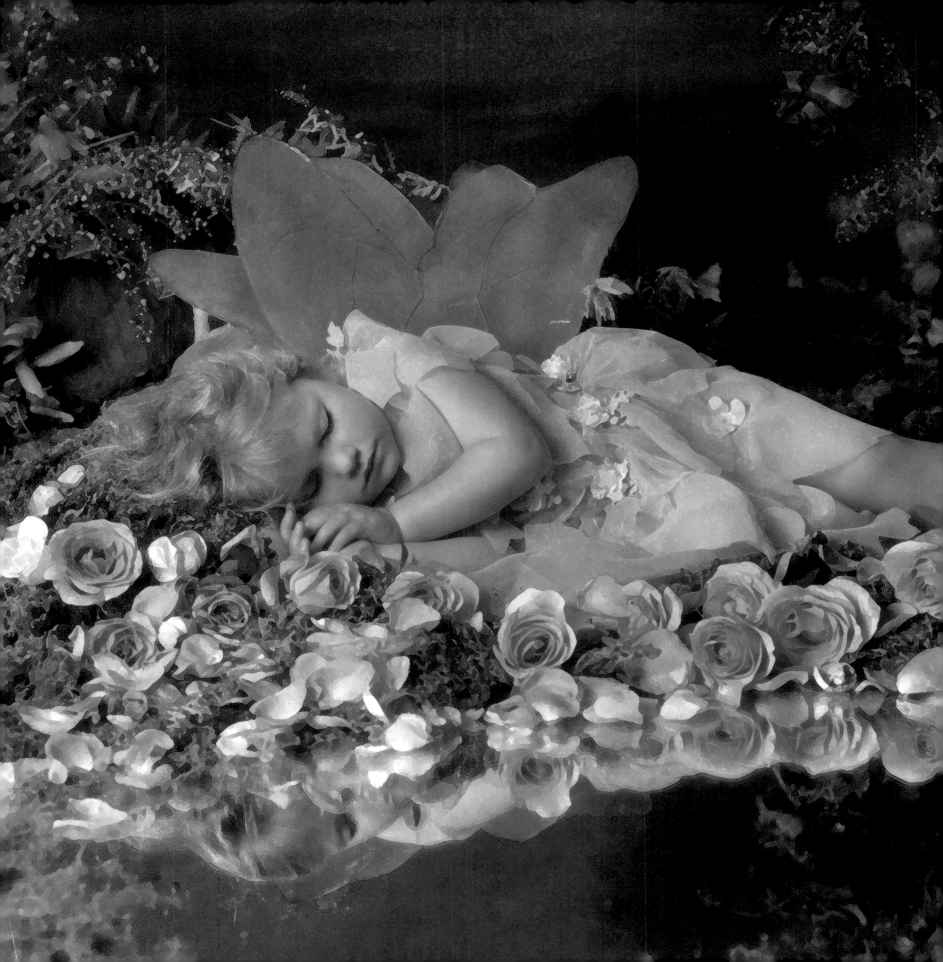

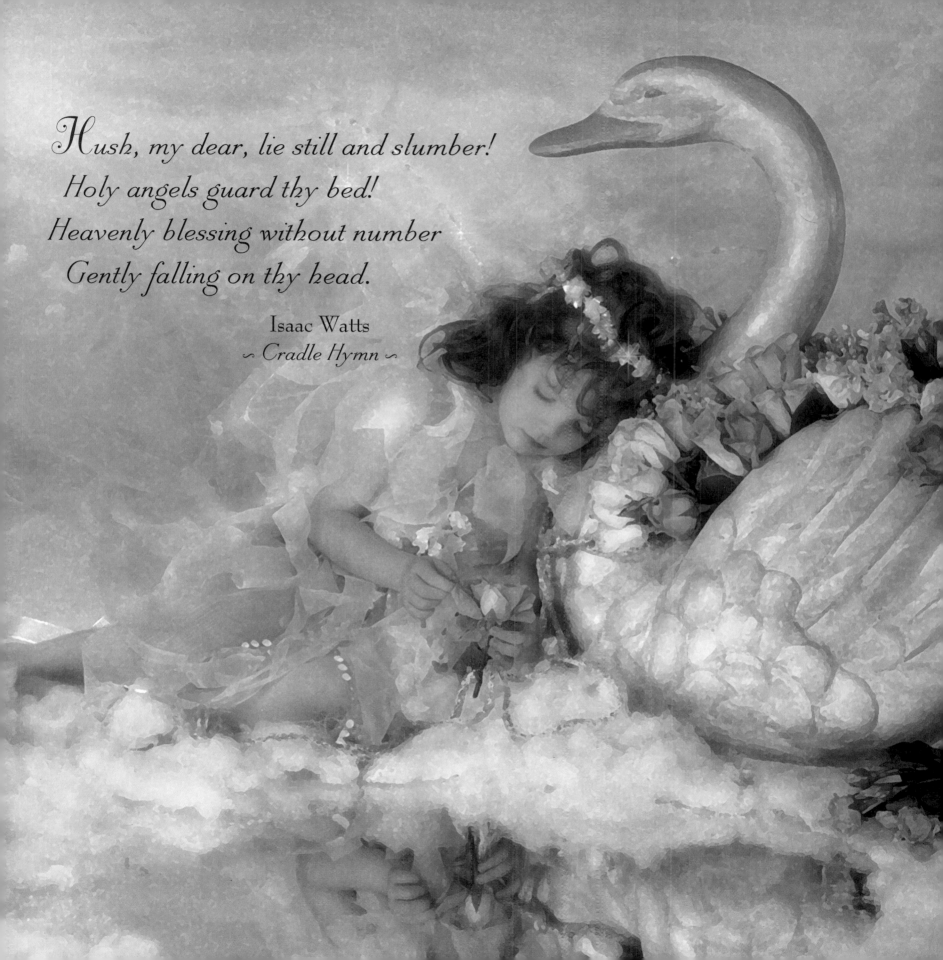

Hush, my dear, lie still and slumber!
Holy angels guard thy bed!
Heavenly blessing without number
Gently falling on thy head.

Isaac Watts
~ Cradle Hymn ~

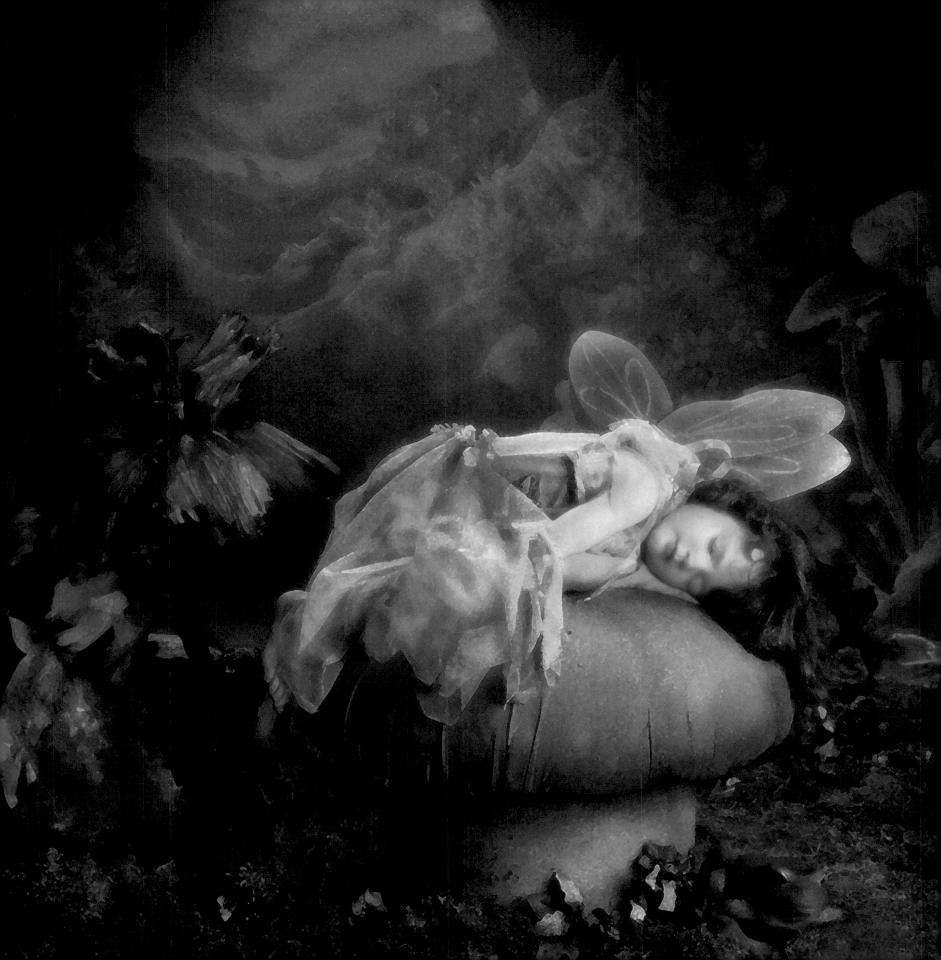

If you see a fairy ring
In a field of grass,
Very light step around,
Tiptoe as you pass;
Last night fairies frolicked there,
And they're sleeping somewhere near.

Anonymous
~ *If You See a Fairy Ring* ~

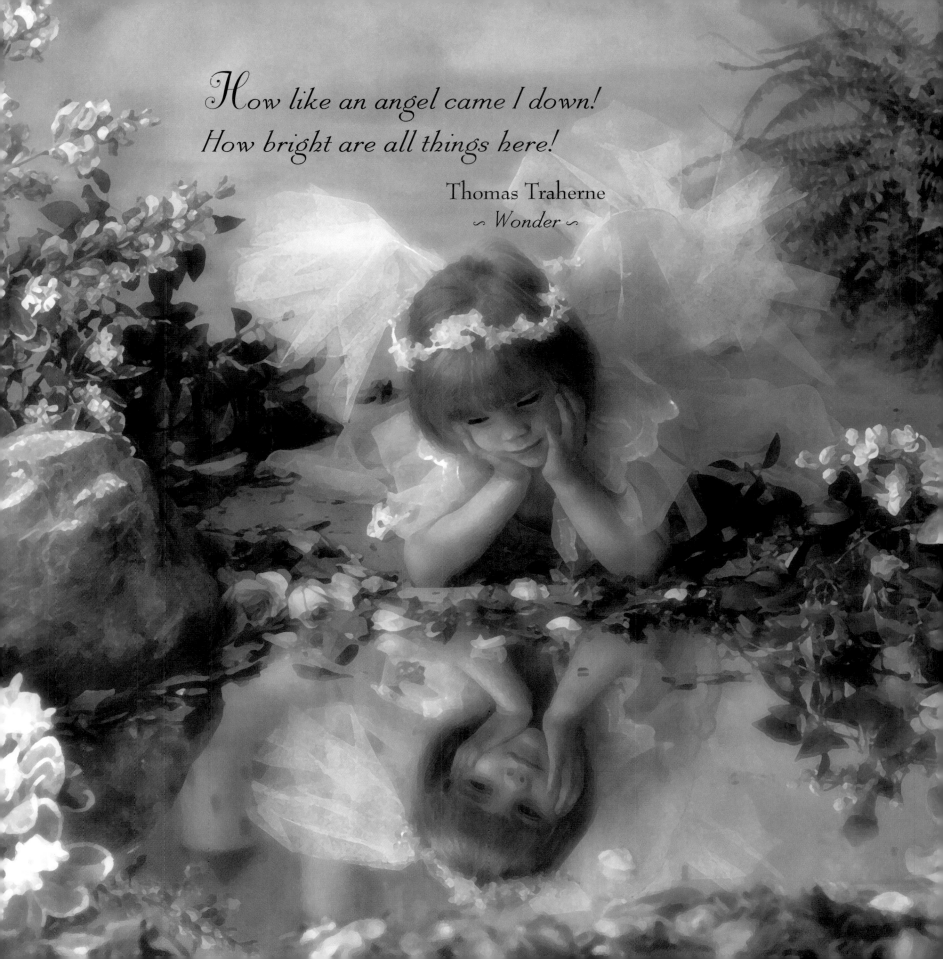

How like an angel came I down!
How bright are all things here!

Thomas Traherne
~ *Wonder* ~

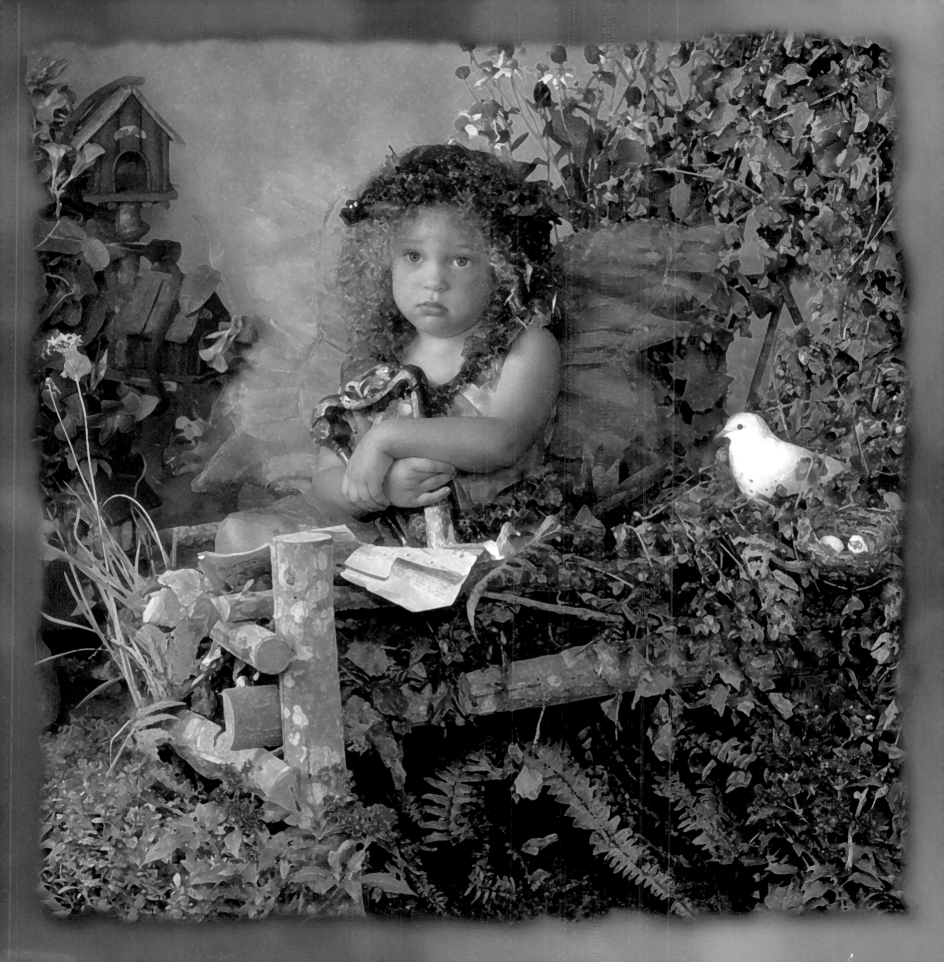

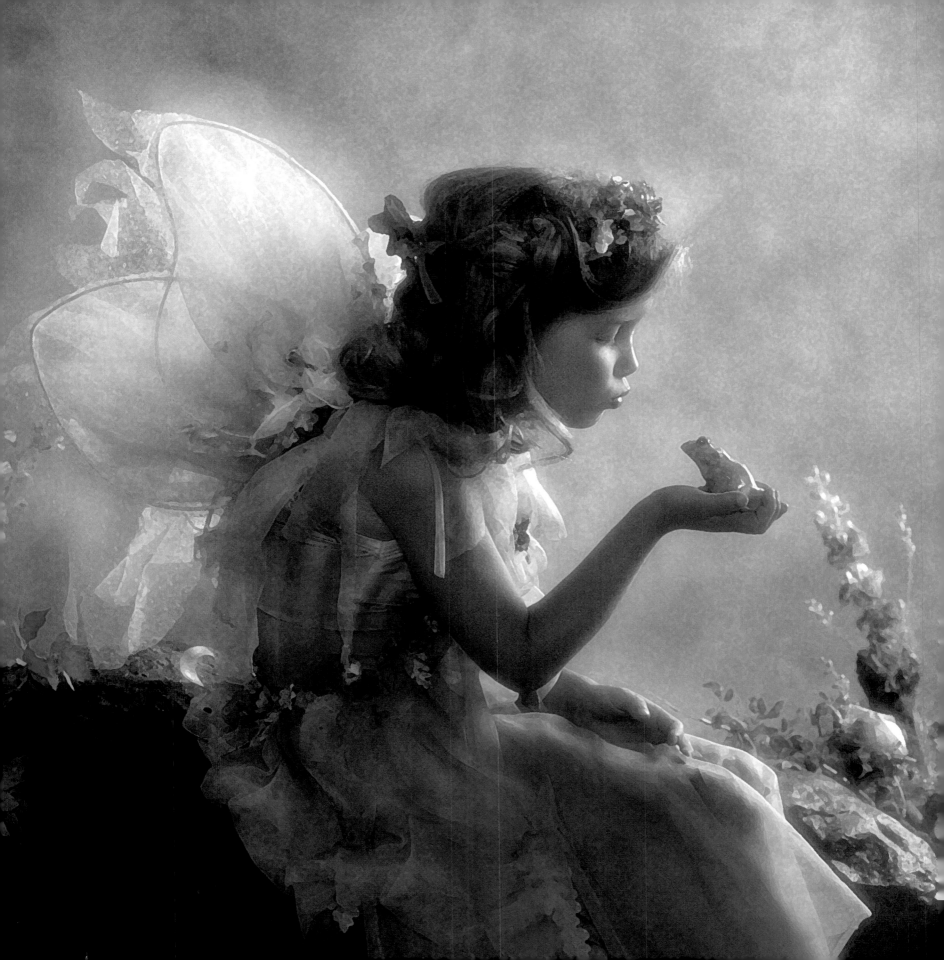

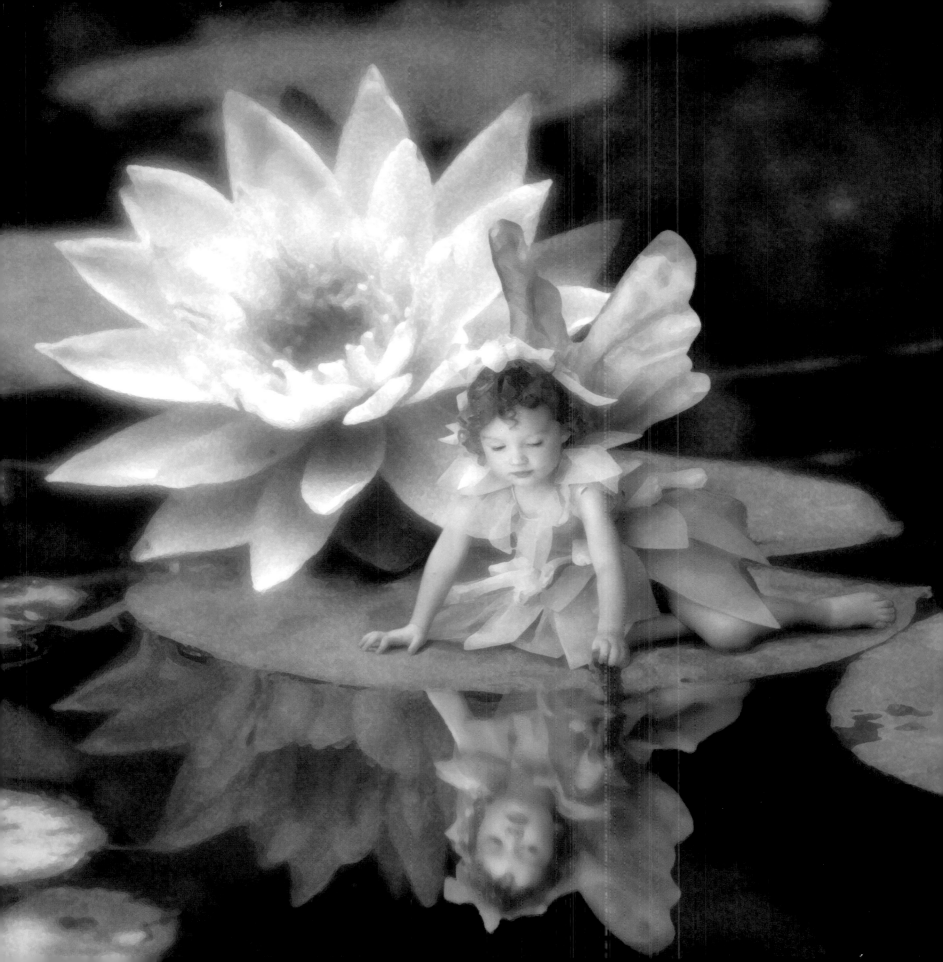

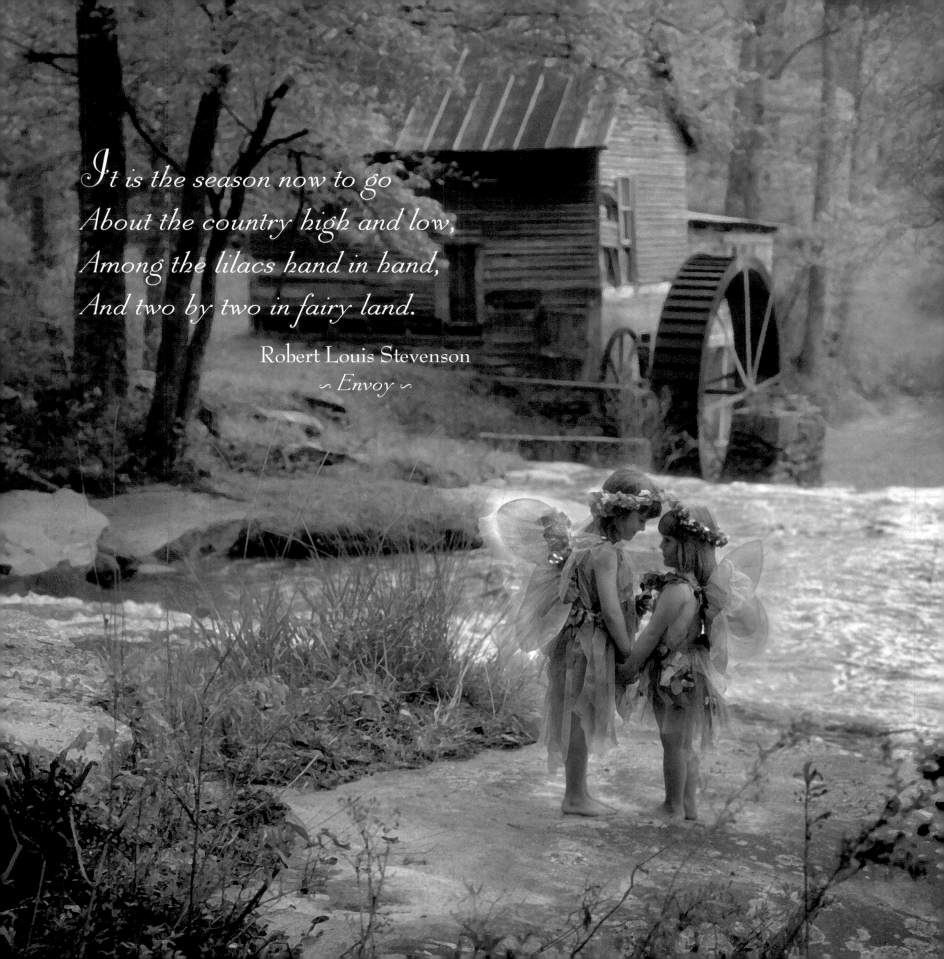

*It is the season now to go
About the country high and low,
Among the lilacs hand in hand,
And two by two in fairy land.*

Robert Louis Stevenson
~ *Envoy* ~

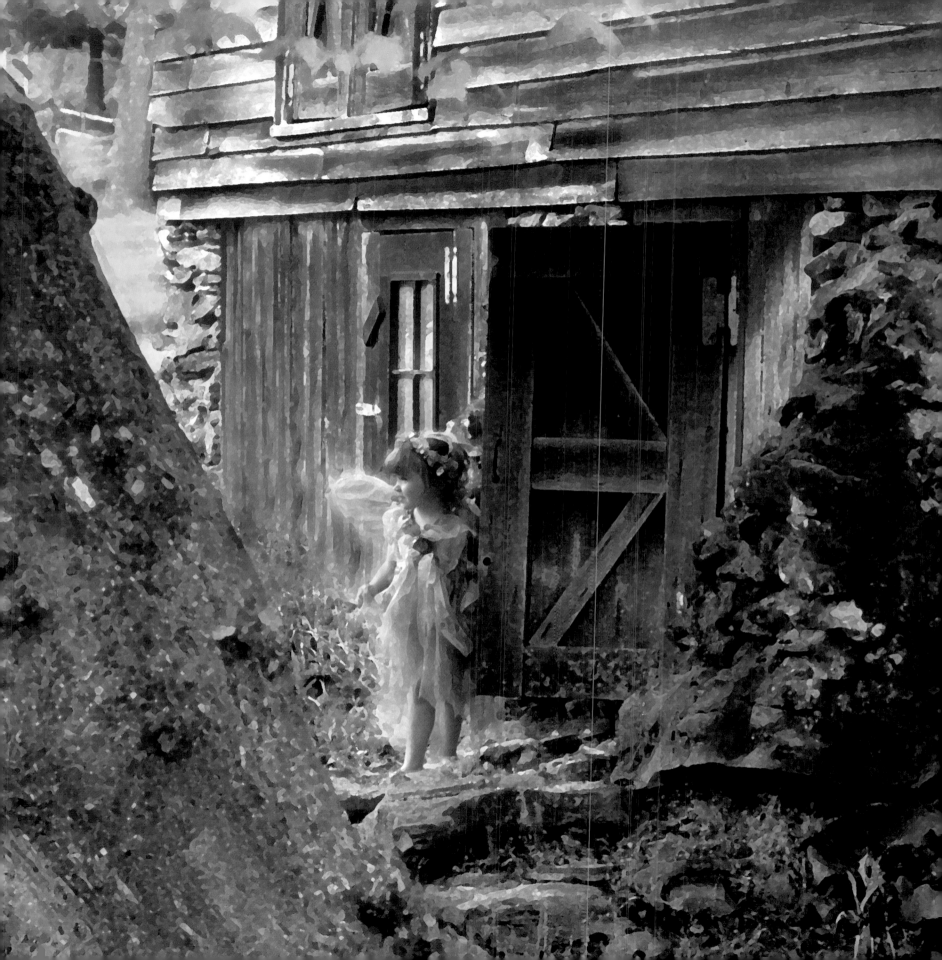

I saw her in childhood—
A bright, gentle thing,
Like the dawn of the morn,
Or the dews of the spring:
The daisies and hare-bells
Her playmates all day;
Herself as light-hearted
And artless as they.

H. F. Lyte
Agnes

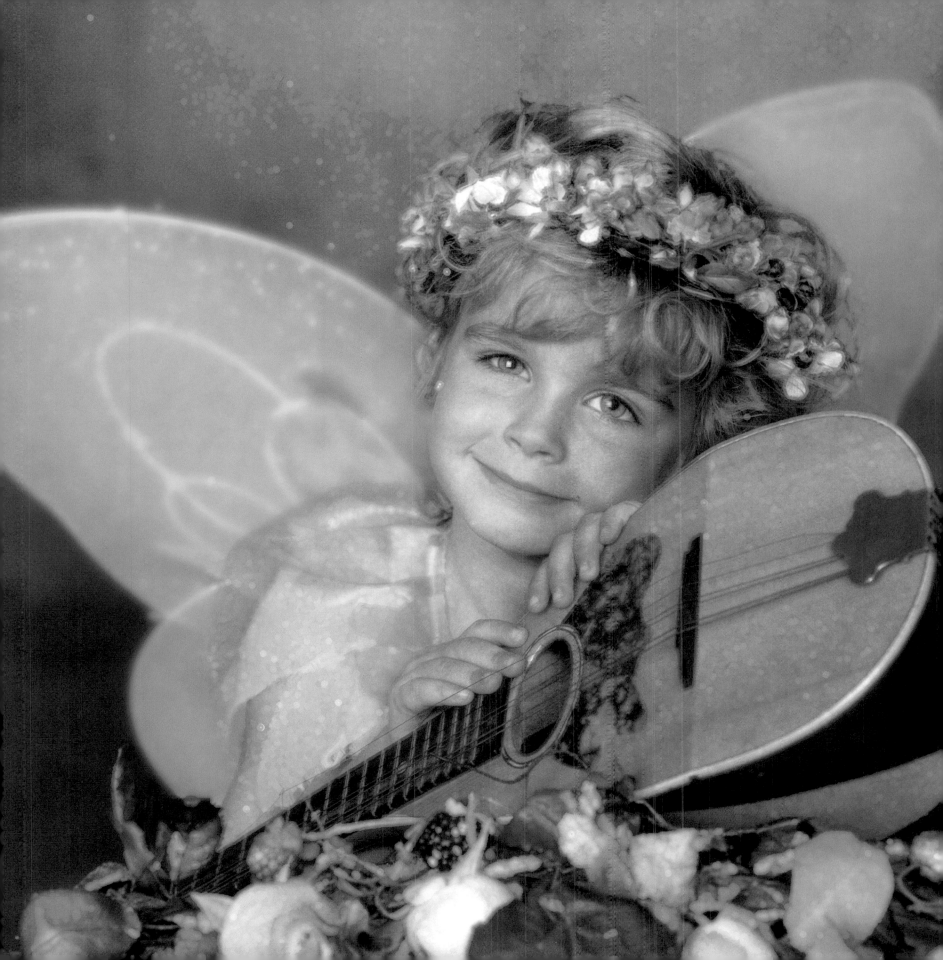

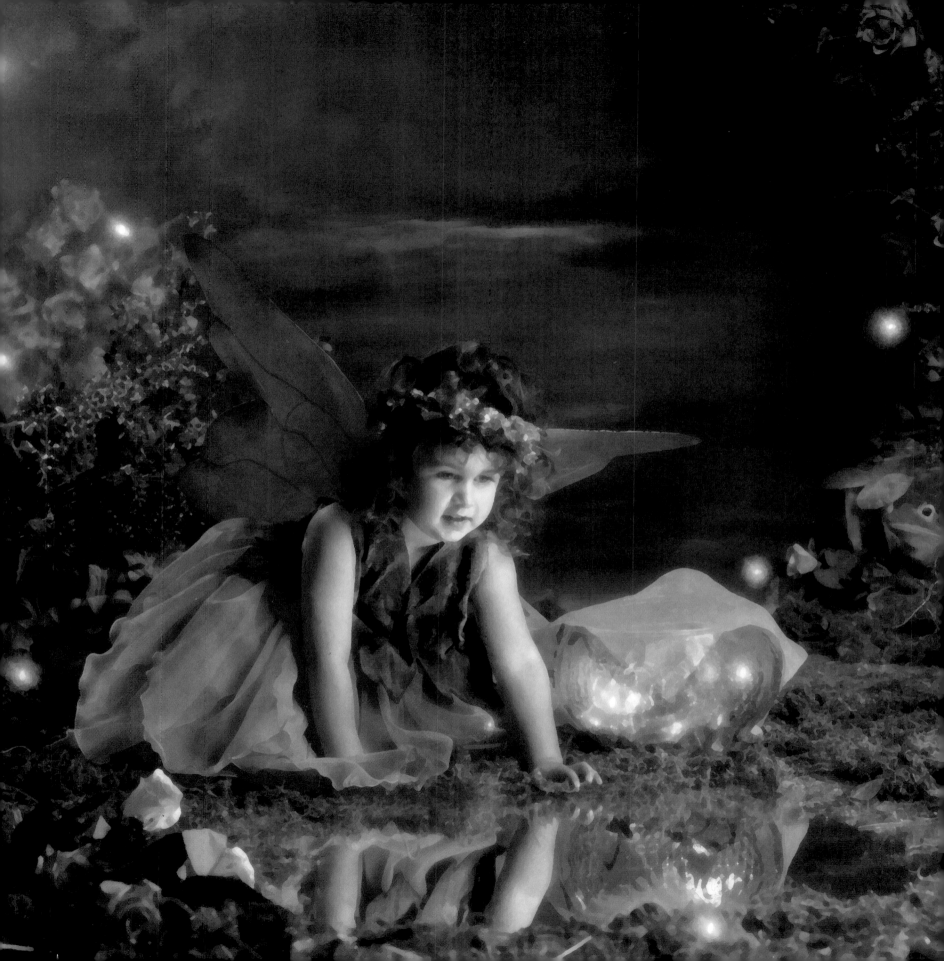

Silver bells!
What a world of merriment their
 melody foretells!
How they tinkle, tinkle, tinkle,
In the icy air of night!
While the stars that oversprinkle
All the heavens, seem to twinkle
With a crystalline delight.

Edgar Allan Poe
~ *The Bells* ~

Then joining hands to little hands
Would bid them cling together,
"For there is no friend like a sister
In calm or stormy weather;
To cheer one on the tedious way,
To fetch one if one goes astray,
To lift one if one totters down,
To strengthen whilst one stands."

Christina Georgina Rossetti
~ Goblin Market ~

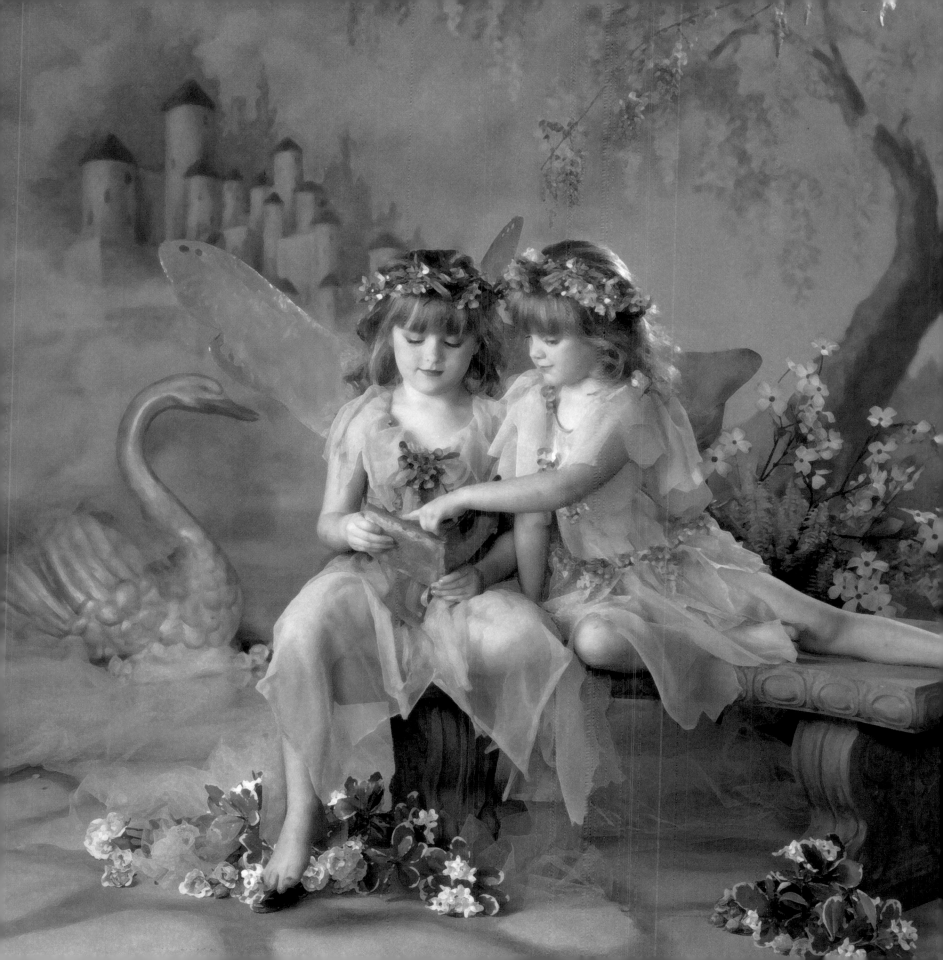

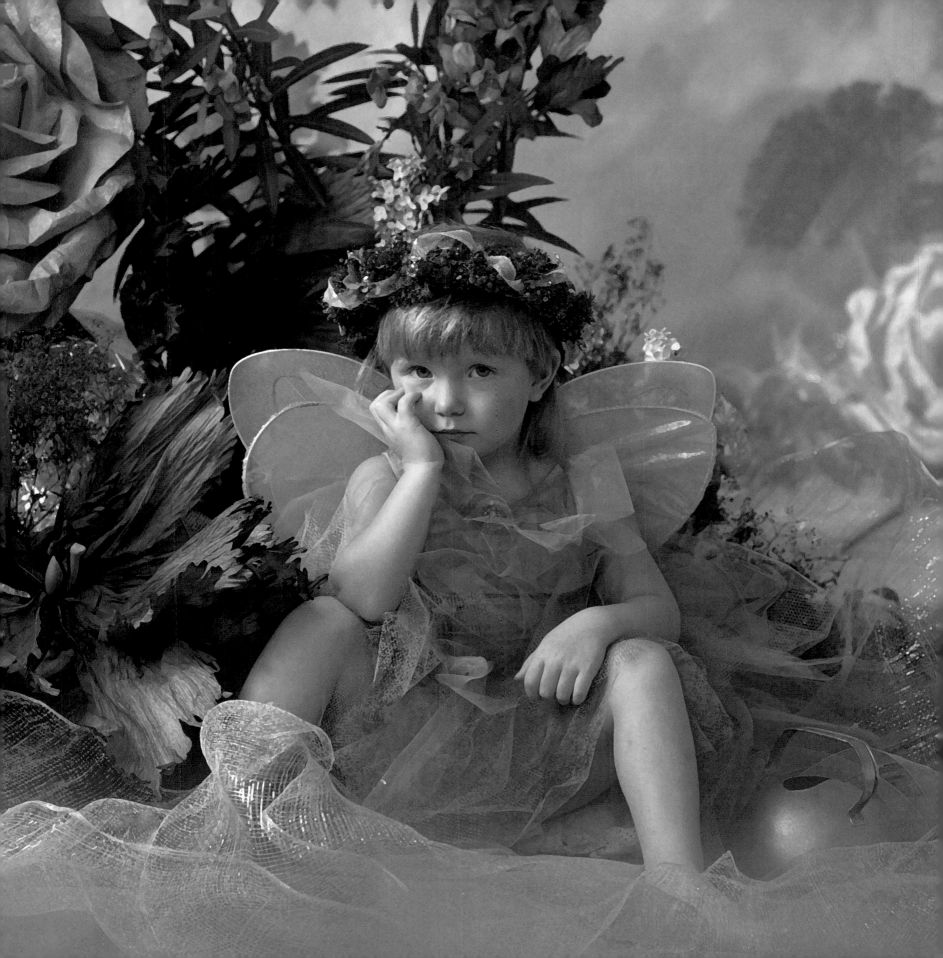

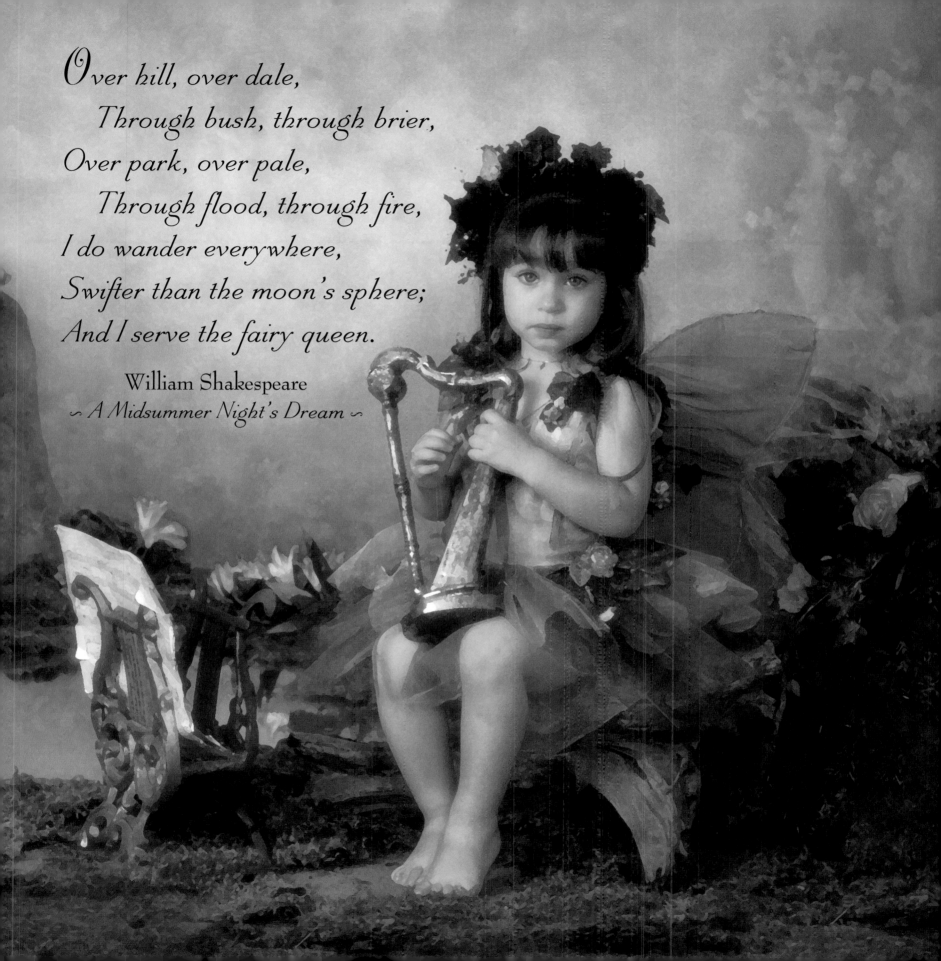

Over hill, over dale,
 Through bush, through brier,
Over park, over pale,
 Through flood, through fire,
I do wander everywhere,
Swifter than the moon's sphere;
And I serve the fairy queen.

William Shakespeare
~ *A Midsummer Night's Dream* ~

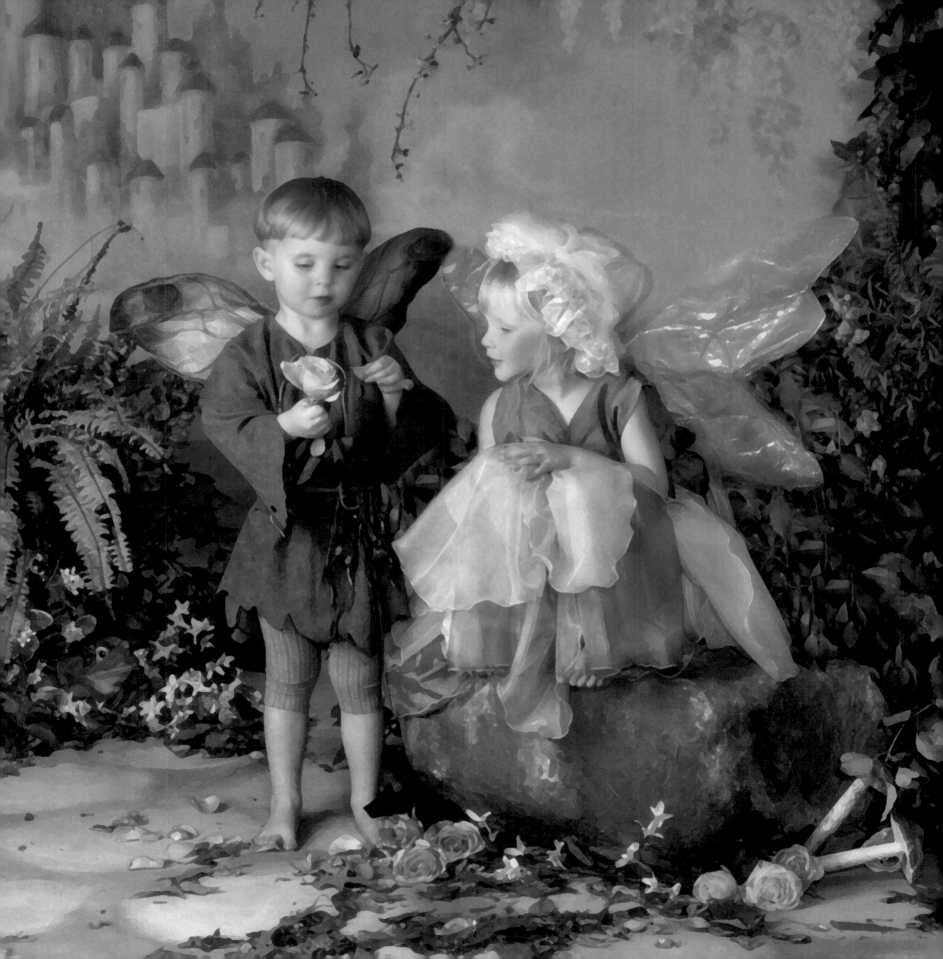

Arise and pick a posy,
Sweet lily, pink and rosy;
It is the finest flower
That ever I did see.

Yes, I will pick a posy,
Sweet lily, pink and rosy,
But there's none so sweet a flower
As the lad that I adore.

~ Folk Song ~

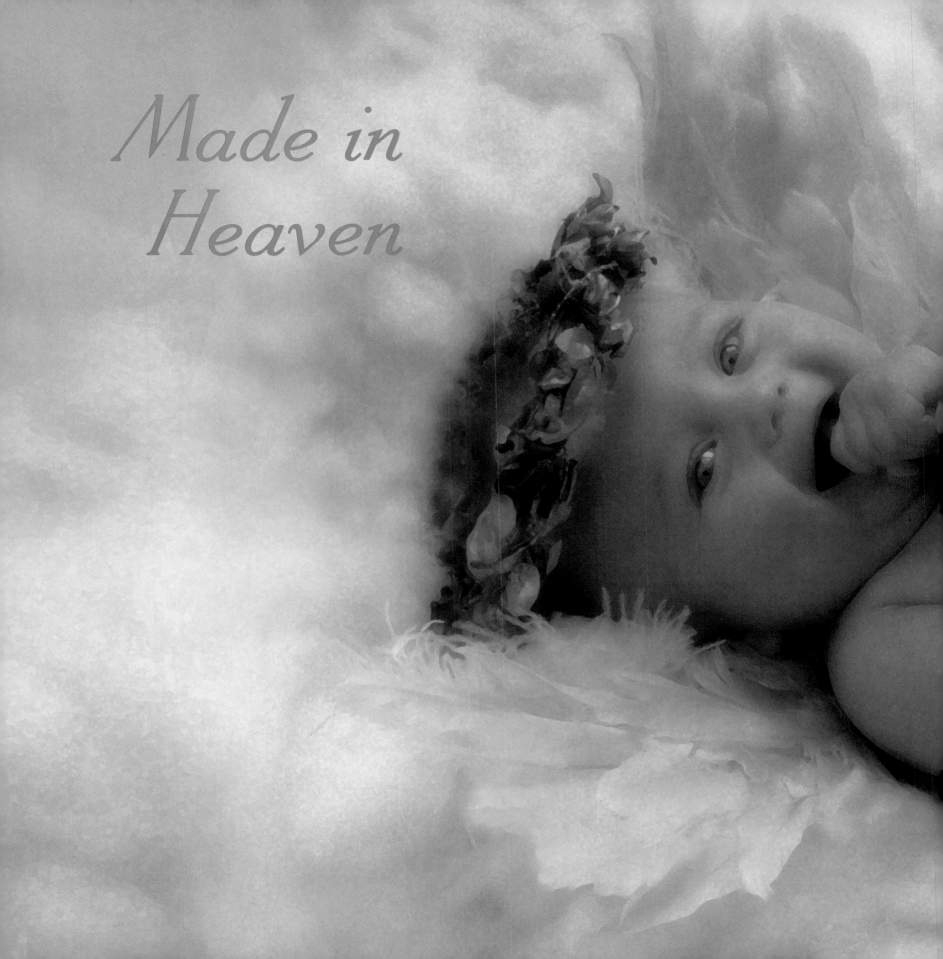

Made in
Heaven

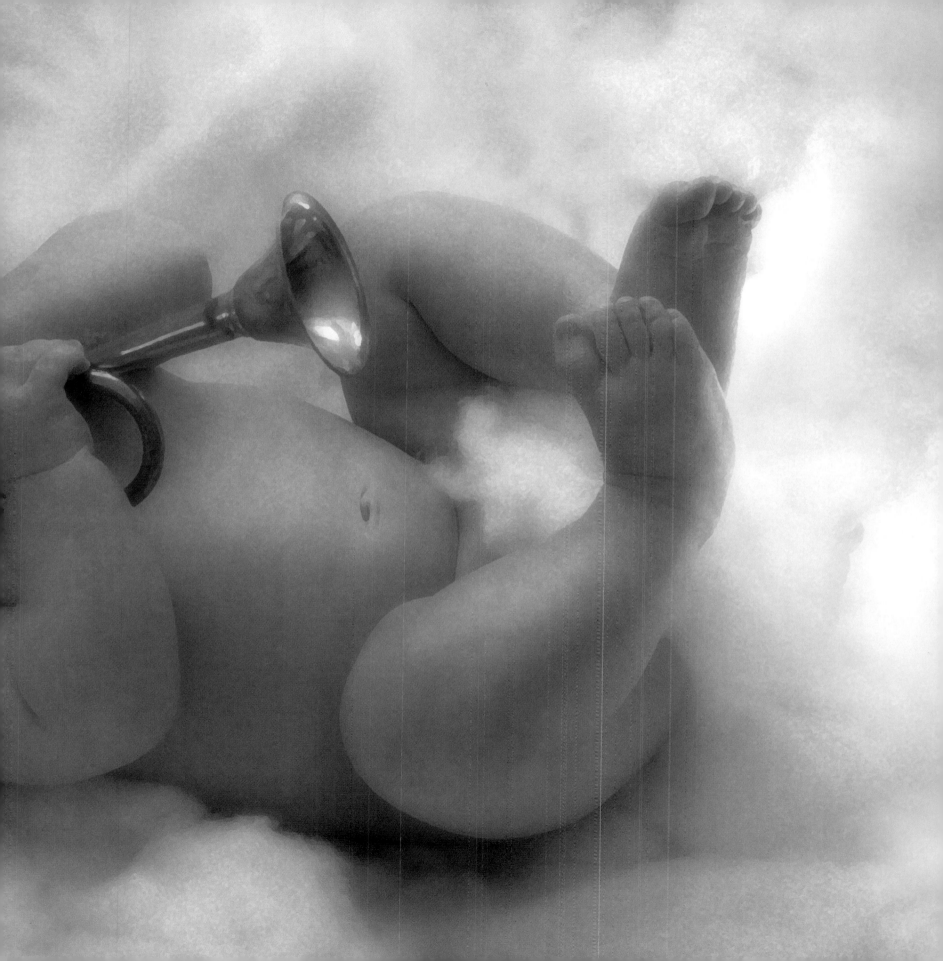

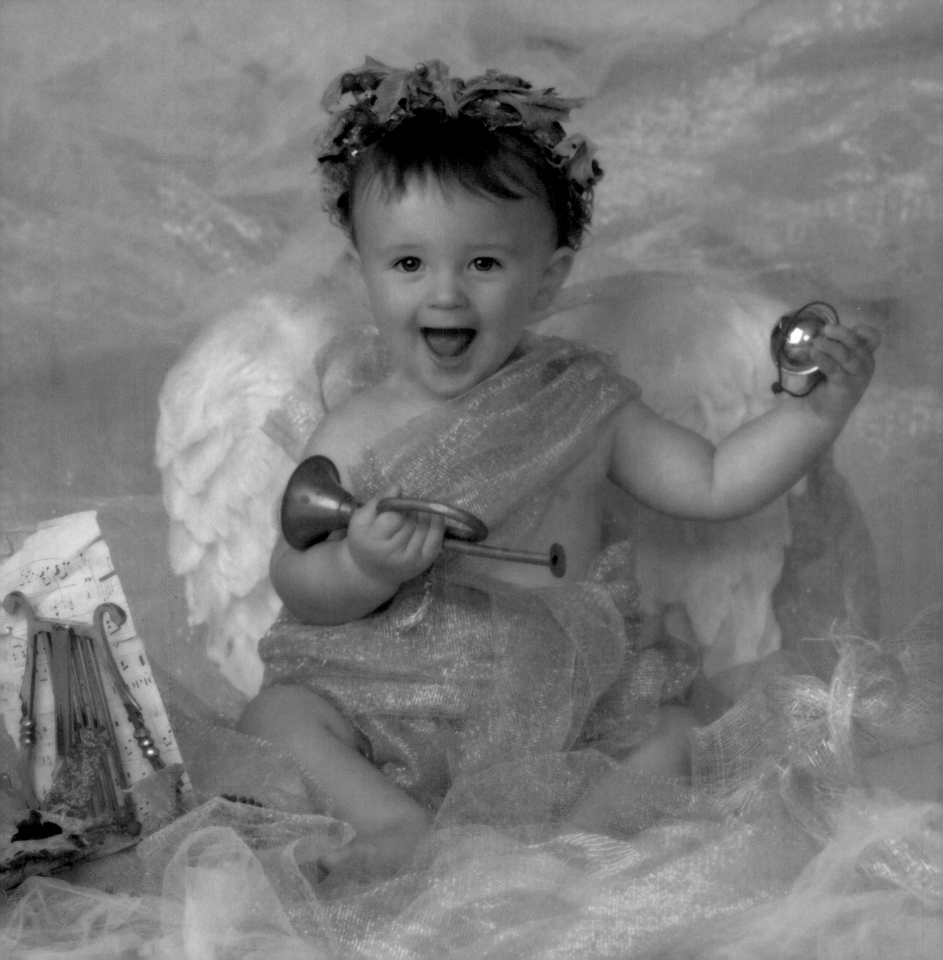

Pretty joy!
Sweet joy, but two days old.
Sweet joy I call thee:
Thou dost smile.
I sing the while,
Sweet joy befall thee!

William Blake
~ Infant Joy ~

Heaven is under our feet as well as above our heads.

Henry David Thoreau

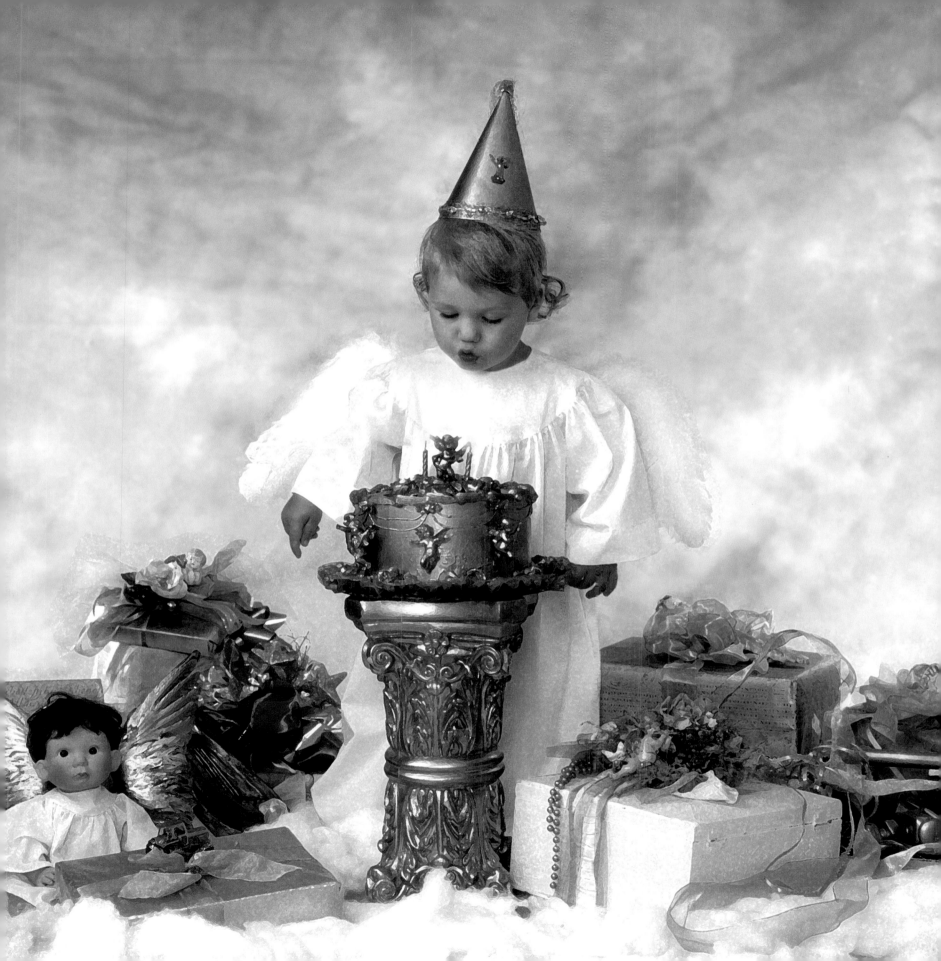

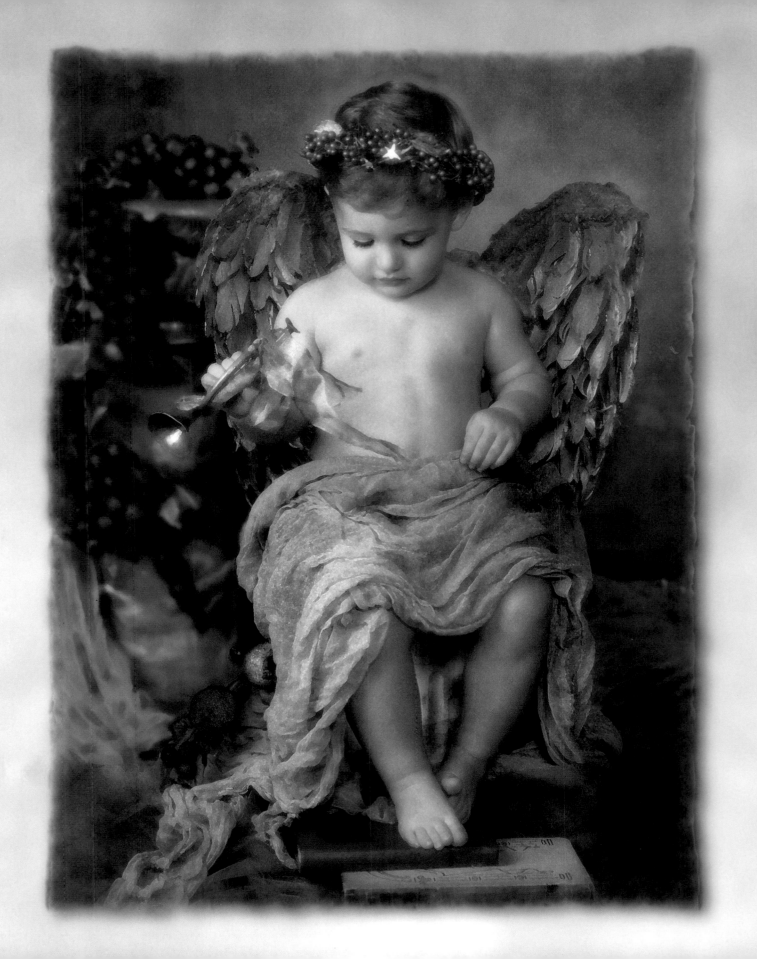

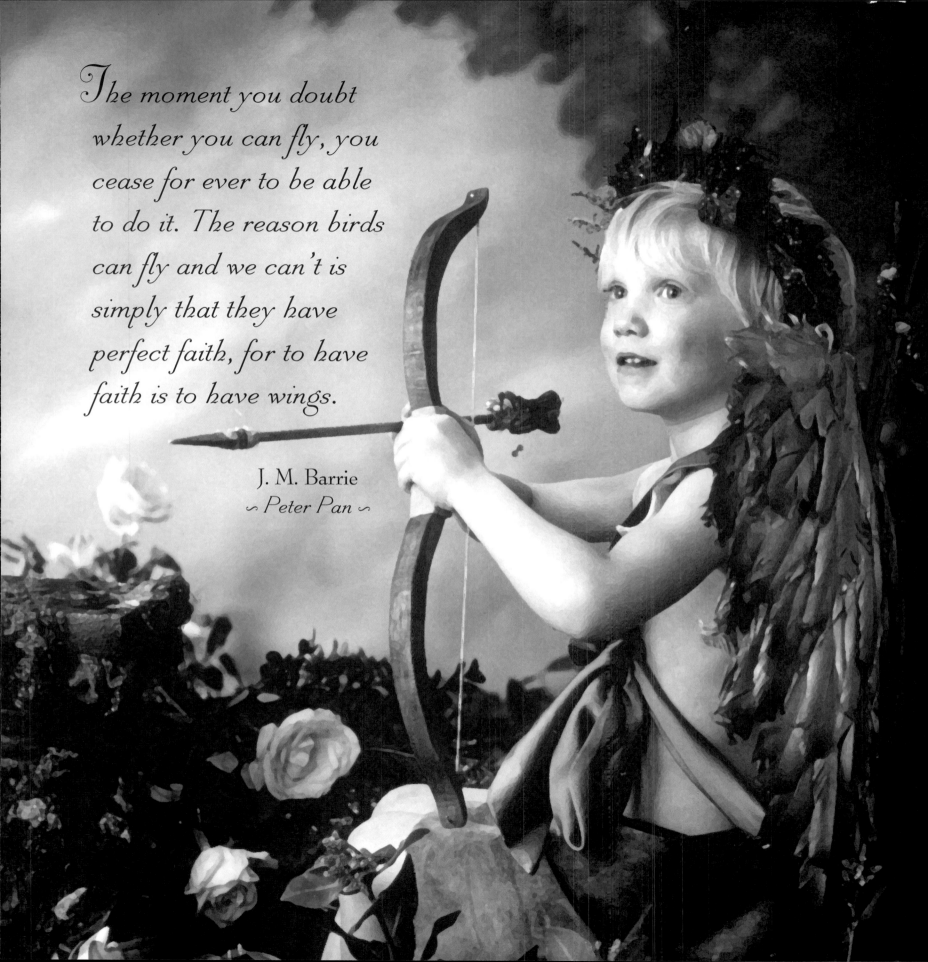

The moment you doubt whether you can fly, you cease for ever to be able to do it. The reason birds can fly and we can't is simply that they have perfect faith, for to have faith is to have wings.

J. M. Barrie
~ *Peter Pan* ~

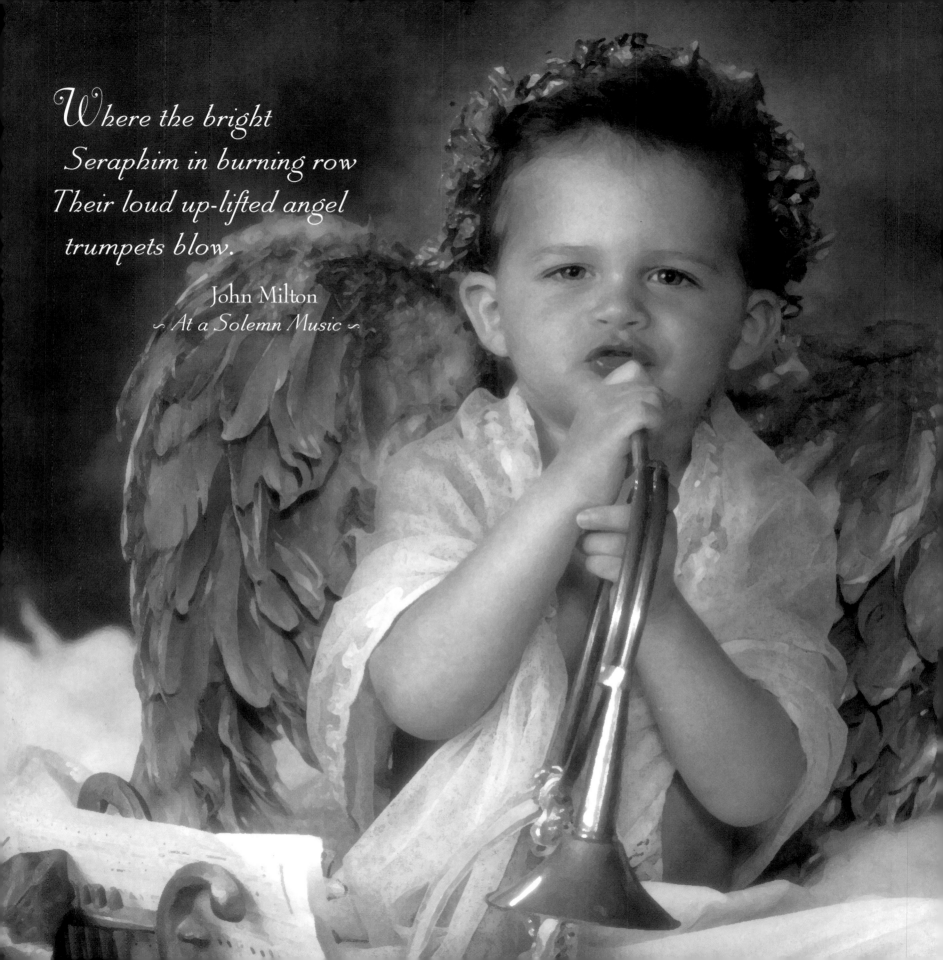

Where the bright
Seraphim in burning row
Their loud up-lifted angel
trumpets blow.

John Milton
~ At a Solemn Music ~

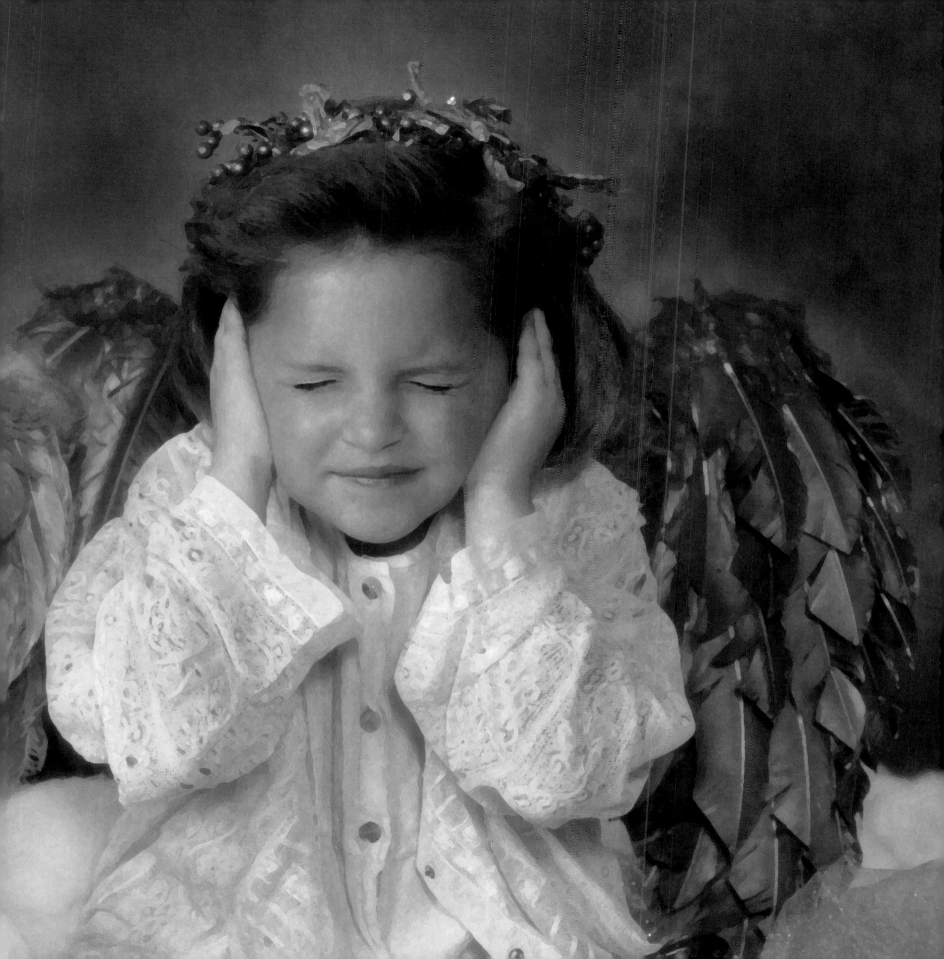

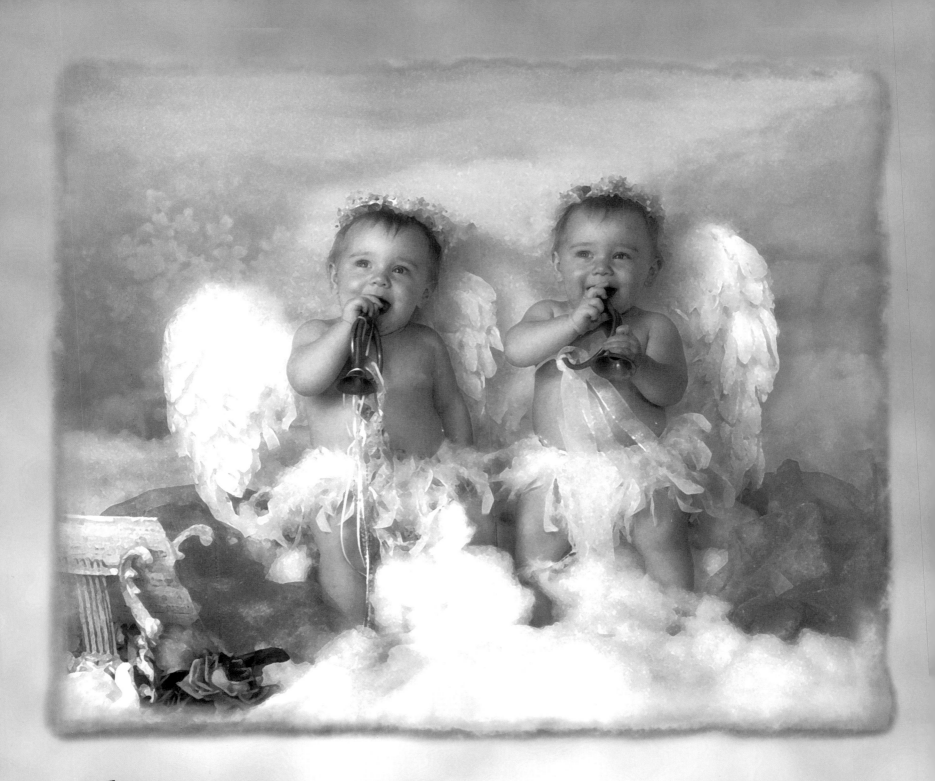

If you're not allowed to laugh in heaven, I don't want to go there.

Martin Luther

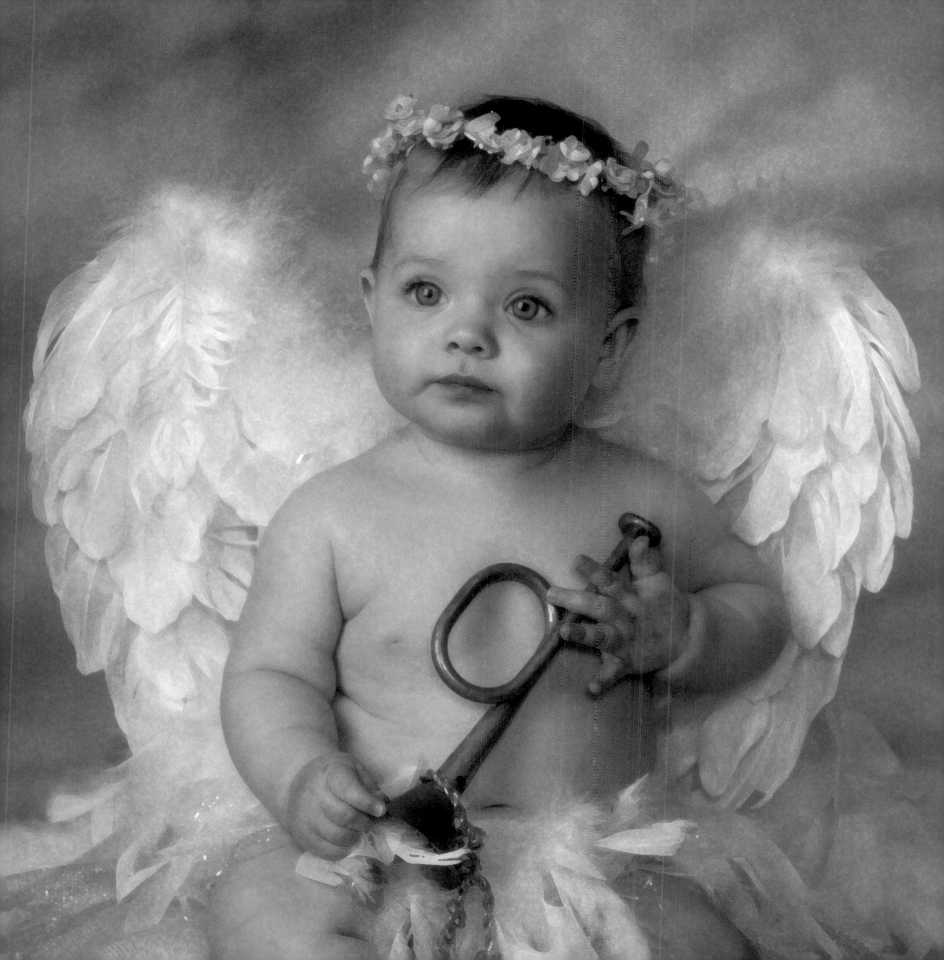

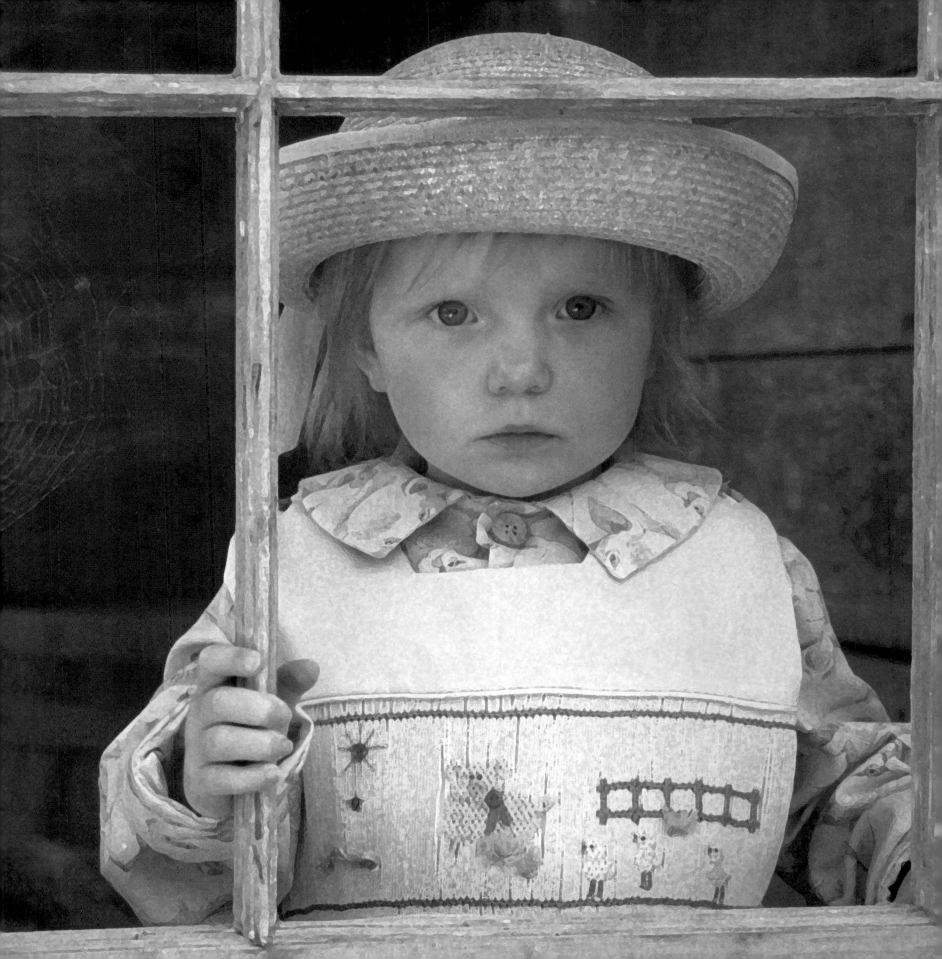

Acknowledgments

A special thank you goes to my loyal staff, friends, and sisters for their affection, support, and prayers, which helped me complete this labor of love—Ramona, Priscilla, Sandy, Bridgett, Angela, Tony, Marie, Maurice, Maricela, Rick, Vicki, Kelly, Janet, Judy, Norma, Lynn, and Libba. Thank you especially to Connie and Michelle, who have always believed in me and who have inspired me beyond words.

My new friends at Abbeville Press—publisher Robert E. Abrams, editor Nancy Grubb, designer Patricia Fabricant, and production manager Lou Bilka—have made the challenging process of creating this book a true pleasure and a genuine collaboration.

I appreciate the wonderful people at United Design for providing us with a frog that really is a prince.

Finally, I would like to thank my parents for always encouraging my creativity and imagination, as well as the parents of the children in this book for allowing me the joy of capturing their children's essence and sharing it with the rest of the world. And I most especially want to thank the children themselves: Abby, Allison, Ally, Amelia, Andrea, Ann, Austin, Becky, Bonnie Rae, Brittany, Caitlin, Caitlin Brooke, Camille, Carson, Chelsie, Cheyenne, Christopher, Christy, Claire, Courtney, Denise, Dustin, Gabriela, Griffin, Harrison, Hollin, Hunter, Jacob, James, Jasmine, Jason, Jessica, Jessica Erin, Jessica G, John Henry, Joshua, Katie, Kristen, Kristen Marie, Madison, Mollie, Morgan, Mykala, Natalie, Nicholas, Nicole, Olivia, Paige, Payton, Rachel, Reagan, Reagan P., Savannah, Shannon, Stephanie, Taylor, and Wesley.

Tools of the Trade

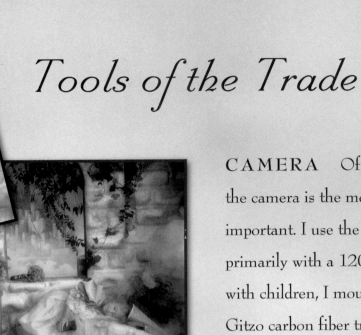

CAMERA Of all a photographer's tools, the camera is the most personal and the most important. I use the Hasselblad 503CW, primarily with a 120 mm lens. When working with children, I mount the Hasselblad on a Gitzo carbon fiber tripod (chosen because of its light weight and versatility). Having a wireless remote to trigger the shutter and a power winder to advance it is invaluable, allowing the camera to become an extension of myself. Because I'm not tethered to a tripod, I can talk and play with the children while pushing the remote button, without ever having to return to my camera to take the picture or advance the film.

I have always relied on Kodak's professional negative films in medium-format sizes.

LIGHTING The quality of lighting in a portrait helps create both a sense of depth and a mood. When working in the studio, I prefer a large, soft light source for my main illumination, in order to simulate natural light. I use a three-by-five-foot soft box by Wescott, usually

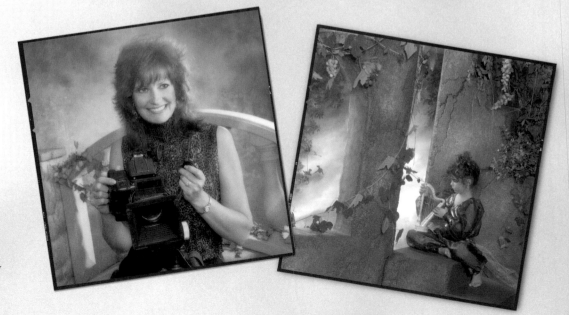

placed at a forty-five-degree angle to the front of the subject. Behind my camera I use an umbrella or halo-mono by Wescott for a fill light, plus a hair light with a small soft box and background lights set up with barn doors.

In the studio I use Powerlights made by Photogenic. For my outdoor lighting I position a Quantum Q-Flash forty-five degrees from my subject to provide a slight fill light; I either bounce it into an umbrella or shoot through a scrim jim diffusion panel.

BACKGROUNDS The backgrounds in my photographs play a very important role because they help create an atmosphere of fantasy. I use large canvases—twelve by twenty feet—hand painted by some of the top artists in the photographic industry, including Terry Larson from Photo Showcase, David Maheau from David Maheau Backgrounds, and Wescott.

COMPUTER With the availability of powerful computers, the state of the art of children's portrait design has evolved rapidly. I used a 300 megahertz Power Macintosh G3 to enhance all of the photographs in this book. Just a few years ago I was still hand painting my photographs to try to achieve the effects I wanted, but with the aid of my Mac I can finally capture the dreams and fairy tales that previously existed only in my imagination.

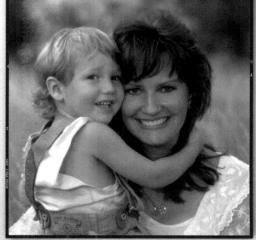

About Lisa Jane

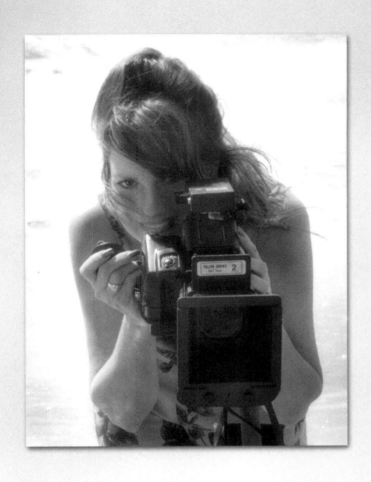

"When at last I took time to look into the heart of a flower, it opened up a whole new world—a world where every country walk would be an adventure, where every garden would become an enchanted one."

<div align="right">Princess Grace of Monaco</div>

Lisa Jane's studio is her own enchanted garden—complete with lily pond, porch, and gazebo—located on three wooded acres in the heart of Houston, Texas. Lisa Jane grew up in the small South Texas town of Portland, near Corpus Christi, and started taking pictures in high school. She has worked as a professional photographer ever since graduating from Sam Houston State University in Huntsville with a Bachelor of Arts degree in photography and a minor in art (the university has since given her an Honorary Professor of Photography degree as well). When she graduated, her father offered her the choice between a Hasselblad camera and a safari to Africa as a graduation present; she took the camera and never looked back.

For over twenty years Lisa Jane's creative talent, impressive technical skills, and distinctive style have earned her virtually every major degree and honor in professional photography, including Master Photographer, Photographic Craftsman, Master of Electronic Imaging, Certified Professional Photographer, and Master Photographer of the Year. Her prints have garnered additional awards for her, such as the President's Trophy, Best Portrait of a Child (eight times), and Photographer of the Year. In 1995 Lisa Jane

self-published her first book, *The Essence of Childhood*—a compendium of advice to professionals about how to photograph children—and it has been tremendously popular at the photographic conferences and conventions where she regularly speaks.

Lisa Jane, who frequently travels around the country sharing her talents in professional photographic seminars on children's portraiture, is a member of Eastman Kodak Company's elite professional group, the Kodak Pro Team. In addition, she teaches in the traveling Hasselblad University lecture series. Her work has appeared in national and international ads and publications by Kodak, Hasselblad, and others; numerous articles have also been devoted to her in magazines including *Petersen's PHOTOgraphic, Professional Photographers, Rangefinder, Sew Beautiful, Storytellers, Studio Magazine, Texas Professional Photographers, Victoria Sampler,* and *Viewfinder.*

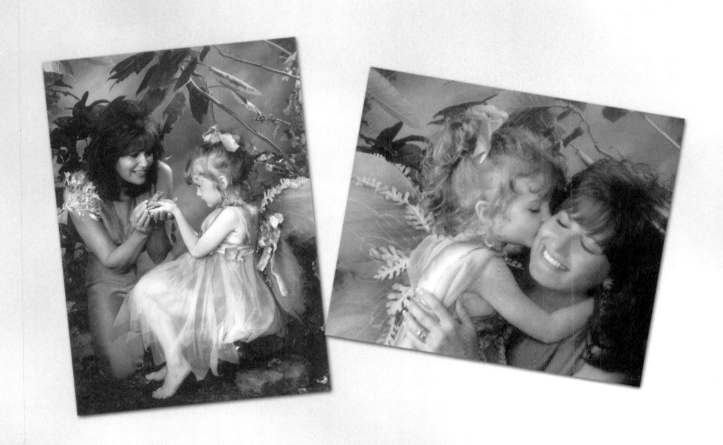

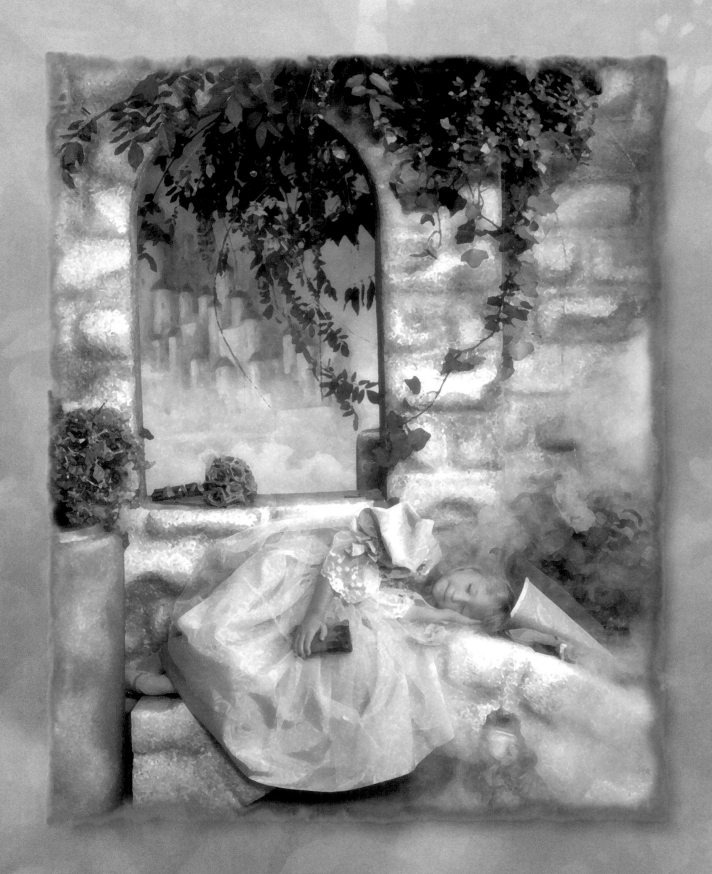